5-MINUTE SKETCHING

ARCHITECTURE

First Published in the UK in 2016 by
APPLE PRESS
74-77 White Lion Street
London N1 9PF
UK

www.quartoknows.com

10 9 8 7 6 5 4 3 2 1

ISBN: 978-1-84543-661-2

Publisher: Mark Searle
Editorial Director: Isheeta Mustafi
Commissioning Editor: Alison Morris
Editor: Nick Jones
Junior Editor: Abbie Sharman
Cover design: Michelle Rowlandson
Layout: JC Lanaway

Image credits:

Cover: Liz Steel
Opposite: Peter Andrews

5-MINUTE SKETCHING

ARCHITECTURE

Super-quick Techniques for Amazing Drawings

LIZ STEEL

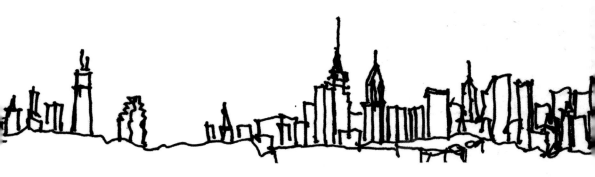

APPLE PRESS

Contents

Chapter 3

TIME-SAVING TECHNIQUES 74

Chapter 4

SPEEDY SUPPLIES 104

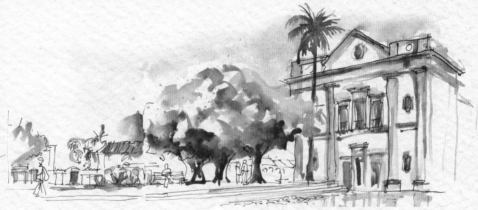

Introduction

THE MOST COMMON MISCONCEPTION about sketching architecture is that it must involve perfect perspective and the diligence to draw every brick. So the ability to sketch a building quickly in five minutes might seem impossible. But it's not! The secret lies in having a visual understanding of buildings and a few strategies in place to simplify what you see. And as for perspective, it honestly is not as essential as you think it is!

My love of buildings goes back to my childhood. I was drawing and designing houses as a 10-year-old, so it is not surprising that I grew up to be an architect. Despite the digital age in which we now live, I still maintain a strong emphasis on freehand drawing in my architectural work as a way to explore ideas while designing. I also have a great personal interest in the history of architecture and have spent many years analysing masterpieces from around the world through notated drawings.

When I started urban sketching, I discovered that my design background helped me enormously to sketch quickly – it gave me a conceptual framework to analyse what I saw. Combining basic observational drawing with these architectural skills is what I want to share with you in this book.

Can architecture be sketched in five minutes? Yes, it can, but it comes with its limitations. You will have to focus your story on the most essential part, concentrate on big shapes or just zoom into a small detail, limit the tools you use and let go of high expectations for accuracy. Not every sketch in this book was completed in five minutes, but they were all sketched quickly, and within the first five minutes the essence of the sketch was established on the page. So by focusing on one aspect, or technique, try to 'nail it' by the five-minute mark.

In Chapter 1 we will look at the essential skills you need to sketch quickly. Chapter 2 will apply these skills to different building types, focusing on telling a story about each. Then, in Chapter 3, we will explore different ways of quickly using line and colour. Chapter 4 explores how to use different tools to their best advantage for fast sketching, and how to decide which ones suit your approach best. Once you have built your own kit, a working knowledge of it will be essential to using it quickly.

Ultimately, the best way to sketch architecture quickly is to start doing it, to focus in on what interests you the most, to simplify what you see and then go for it and have fun!

Liz Steel

Below **Liz Steel, *Central Station, Sydney, Australia*, 2015.**
Simplifying this complex building into three elements – the tower, the green awning and the rest of the building – made it quicker to sketch.

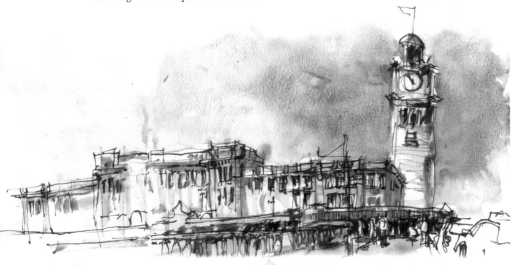

Key architectural elements

Despite the uniqueness of every building we sketch, there are often common characteristics. Understanding a few key elements of Western architecture, coupled with the techniques described throughout this book, will aid with quicker sketching.

Three basic architectural styles to understand

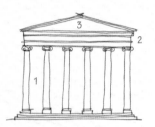

Classical architecture
A style of architecture based on a Greek temple, which includes a series of columns called the classical orders (1), supporting a horizontal band called an entablature (2), with a pediment above (3). Looking for these key elements is always a great place to start.

Gothic architecture
Originating in the 12th century, its features include pointed arches, buttresses, vaults and rich decoration. Always start with the big volumes, especially when drawing a complex structure like a cathedral.

Modern architecture
There are many disparate styles that are described as modern, but a few common themes are bold forms (either geometric or sculptural), simple windows, minimal decoration and use of innovative materials.

Quick ideas for key architectural elements

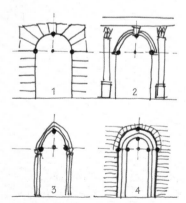

Arches
Look for the two points at the base of the arch and then the highest point before connecting the dots (1). They can be incorporated with classical orders (2), pointed in Gothic architecture (3) or combined together for concentric arches (4).

Balustrades
These are found on the tops of buildings and balconies. Look for the top rail (1), bottom rail (2), pedestals (3) and the balusters (4). Quick tip: draw the top rail and pedestals first.

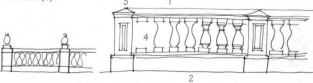

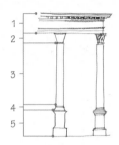

Classical orders

There are five standard systems of structure in classical architecture. Look for the key components: entablature (1), column capital (2), column shaft (3), column base (4) and an optional pedestal (5).

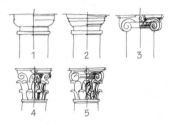

Callouts

(1) Tuscon, (2) Doric, (3) Ionic, (4) Corinthian, (5) Composite.

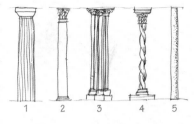

Columns

Columns set out the structure of a building and have distinctive proportions. A few examples: Greek Doric (1), Roman Corinthian (2), Gothic piers made up of numerous thin shafts (3), Baroque twisted column (4) and a slim plain modern pillar (5).

Domes

Start with the profile of the dome (1) and then make sure that the features on the top align with the centreline (2). There are many different types of domes (3) but the principles are the same for all.

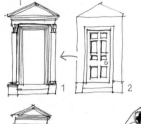

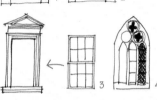

Door and window treatments

Start with the external elements that surround the door/window, which might include classical orders and pediments (1). Add decorative panels to the door later only if needed (2). With windows, add the thickness of the frame if the drawing scale permits (3). With complex designs, start with the geometry of main elements (4).

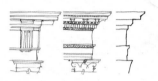

Entablatures

Although these horizontal bands in classical buildings are very complex, focus on the end profile first and add details as necessary afterward.

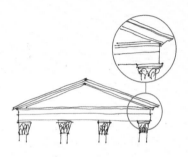

Pediments

These are the triangular sections on top of entablatures; once again, look for the edge details.

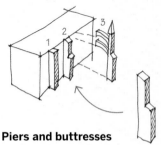

Piers and buttresses

Piers are a thickened section added to a wall to add support (1) and are often called buttresses and highly decorated in gothic architecture (2). Flying buttresses are those with piers separated from the wall by arches (3).

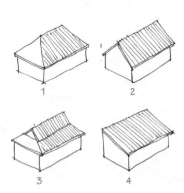

Roof forms

Learn to distinguish between gabled (1) and hip (2) roof shapes to make it easier when combined (3). Lean-to or skillion roofs (4) are even easier.

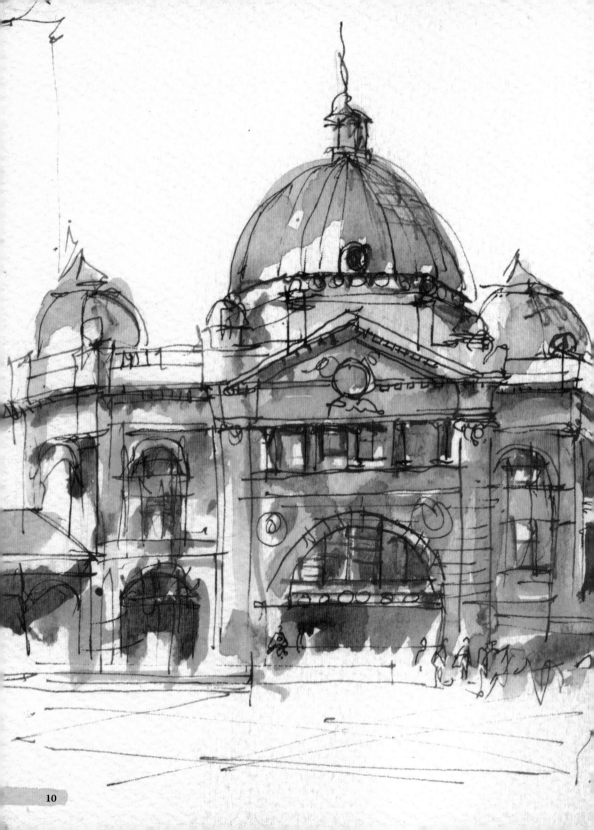

How to see

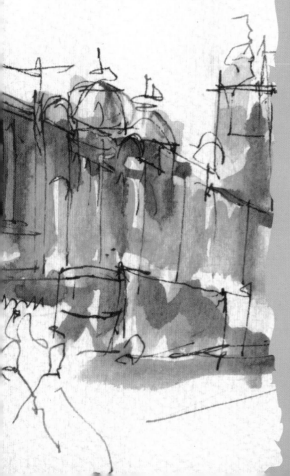

Sketching architecture quickly is not just a matter of fast hand movements – although that helps at times! It is all about being well grounded in basic observational skills – such as seeing shapes and relationships – combined with a way of looking at buildings that helps you simplify them. Seeing buildings in terms of volumes and working in a structured way will make the more technical skill of perspective much easier to manage. The starting point is making sure you are clear about what aspect of your subject interests you the most – what the story of your sketch should be.

Left **Liz Steel, *Flinders Street Station, Melbourne, Australia*, 2013.** In order to sketch this massive complex building quickly, I focused on the main façade and simplified the details on the side.

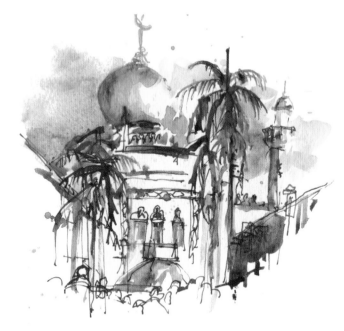

Right **Liz Steel,** *Sultan Mosque,*
Kampong Glam, Singapore, 2015.
I started with the gold dome and then
simply hinted at the busy street of
stores lined with palm trees.

Below **Virginia Hein,**
Pasadena City Hall,
Pasadena, California, 2013.
Virginia zoomed in to focus on the
fancy entrance to this grand city hall
and the equipment being unloaded
from a truck for a big event.

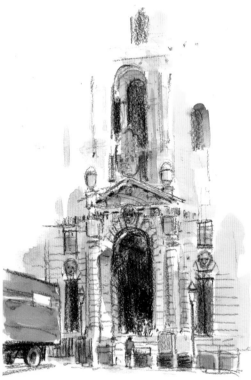

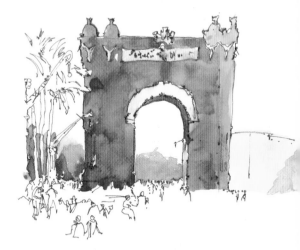

Above **Daniel J. Green,** *Arc de Triomf,*
Passeig de Lluis Companys,
Barcelona, Spain, 2013.
Daniel's selective lines give the viewer
lots of information about this highly
decorative arch and its surroundings,
without drawing it all.

Find your story

The most important step in fast sketching of architecture is the very first one. The few moments that you spend thinking about your subject before you start can radically reduce the time taken to do the sketch. It will give you a focus, a story to tell, so that you don't have to draw everything. You will be able to say more with less!

Tips to get you started

1 **What interests you** Ask yourself, as you look at the scene, what your eye is drawn to the most. Trust this initial response, even if it's only a seemingly insignificant part. Your personal preference and interpretation is the most important ingredient in any artwork you create, as it makes it uniquely yours.

2 **Dominant feature** Often you will be drawn to the dominant feature of the building, such as a dome or grand entrance. How does this relate to its surroundings? Can you see it from a distance? Is the building aiming to make a bold statement or blend into its environment? These factors are prompts for your story.

3 **Zoom in** If sketching the whole building seems a little overwhelming, walk up closer and just focus on one part. There is a lot that can be said about the big picture from sketching a small section, particularly if it hints at the whole.

4 **Zoom out** On the other hand, the further back you go, the less detail you will need to draw. Zooming out reduces the building to its most basic elements so you can focus on big shapes and how they relate to their surroundings. Detail is often a time killer, so reducing it is always a goal in fast sketching.

5 **Time frame** It is always important to consider how long you have to complete your sketch before making a single mark. If all you have is just a few minutes, you will only be able to record one aspect of your subject. What is the one thing that you absolutely must record? It's all about prioritizing!

Begin with composition

Once you have decided what your story is going to be, you need to determine how it is going to fit on your page. Once again, a few moments to consider this at the beginning makes it so much easier to progress with confidence and speed. Your sketch might evolve as you work, but at least you have started out with intention.

Tips to get you started

1 **Start with focus** The focal point is the area where you want the viewer's eye to be drawn, and it is integrally connected with the story you are trying to tell – essentially, it's the hero. Locating it on the page in a way that enhances the story is your goal.

2 **Orientation** Consider which format – portrait, landscape or square – will strengthen your story the most. A horizontal orientation is great for explaining big expanses, while a vertical one will give a sense of height. Sometimes exploring a less obvious format can enhance your story. When you are sketching fast, just go with your initial choice and trust your instincts even if you have chosen an orientation that isn't obvious.

3 **Rule of thirds** If your page is divided into a grid of three across and three down, your sketch will be more pleasing if you place your focus on one of the intersections of these lines. The natural tendency is to locate your focus at the dead centre, but if you start in one of these 'third positions', it will be much easier to create a dynamic composition.

4 **Map out the whole** Once the focus is located on your page, quickly add the edges of the main components in your scene. Look especially at the relationships and intersections of the parts. This will only take a few moments but will radically improve your accuracy. Furthermore, this approach will set out the whole sketch, so if you run out of time, you will still have all the parts indicated.

5 **Work spontaneously** An alternative is simply to start sketching your focal point, working outwards from it. This is a fun way to sketch and is especially useful when you have an unknown timeframe, as the most important part is recorded first.

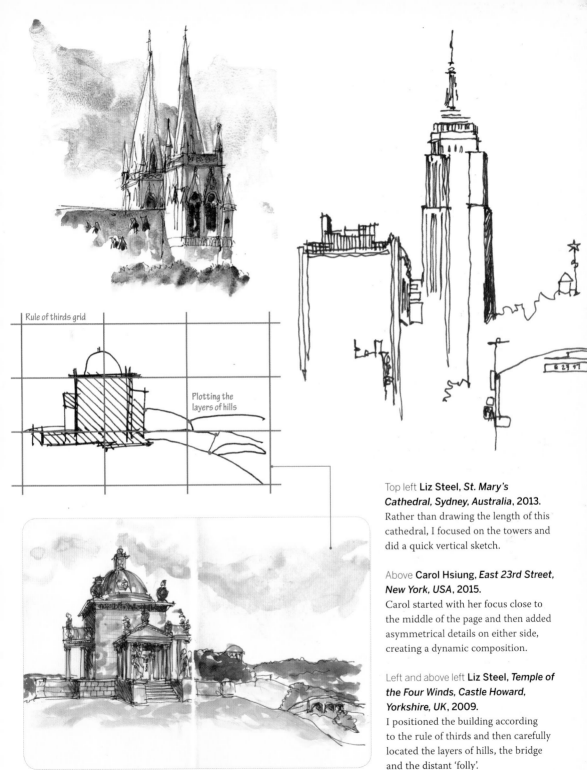

Rule of thirds grid

Plotting the layers of hills

Top left **Liz Steel**, *St. Mary's Cathedral, Sydney, Australia*, 2013.
Rather than drawing the length of this cathedral, I focused on the towers and did a quick vertical sketch.

Above **Carol Hsiung**, *East 23rd Street, New York, USA*, 2015.
Carol started with her focus close to the middle of the page and then added asymmetrical details on either side, creating a dynamic composition.

Left and above left **Liz Steel**, *Temple of the Four Winds, Castle Howard, Yorkshire, UK*, 2009.
I positioned the building according to the rule of thirds and then carefully located the layers of hills, the bridge and the distant 'folly'.

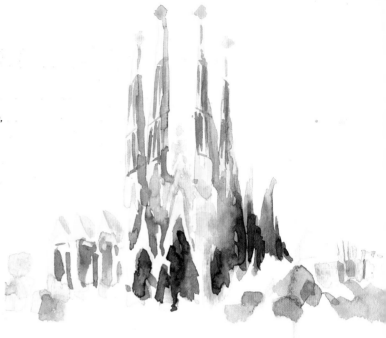

Right Isabell Seidel, *Sagrada Familia, Barcelona, Spain*, 2013.
Isabell has managed to say so much about this extremely complex building by just varying her brush strokes within a few simple shapes.

Left Daniel J. Green, *Weisman Art Museum, University of Minnesota, Minneapolis, Minnesota*, 2013.
Shape sketching is not restricted to using paint. Here, Daniel used colour pencils and worked only with shape and not line.

Right Liz Steel, *Ibrapuera Park, Sao Paolo, Brazil*, 2014.
I started with the sky shape because I was concerned about getting the foreshortening on the side of this triangular building correct.

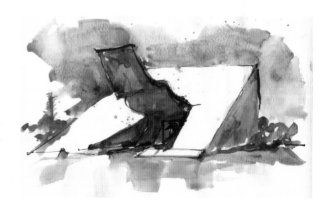

See simple shapes

It is a common misconception that you need perspective to draw buildings. It certainly helps, but it is not as important as developing your ability to abstract the forms in front of you into simple shapes. Simplifying complex objects into shapes is one of the most powerful skills in working fast, and gives you a surprising degree of accuracy in time-critical situations.

Tips to get you started

1 **Think edges** Don't think about whether you are drawing a wall, a roof or a window; just focus on the edges as a series of lines. Think about each line – its length, its angle and how it intersects with adjacent ones. Believe it or not, this thinking will make your sketching faster.

2 **Squint** The best way to abstract three-dimensional objects into shapes is to squint. This will help flatten the scene, and all those distracting details will then disappear. Don't worry how silly you think it makes you look; it's worth it.

3 **Sky shape** The easiest shape to look out for is that of the sky. Just focus on it as a big blue (or grey) shape and draw the skyline, or paint the shape first. It might look a little crazy, but you can then start drawing the building below it, and the result might be surprisingly accurate. This technique is especially useful for extremely complicated buildings with interesting profiles.

4 **Join shapes together** When you are squinting at your subject, try to focus on which shapes are similar in colour or tone and appear to merge together. Sketching these components as the one shape will make it easier to draw quickly. Instead of a multitude of lines describing each change in plane, you can simply put down one wash of colour.

5 **No perspective** If you can develop your ability to see the lengths and edges of the big shapes, you will find a lot less need for perspective. In fact, you might find that focusing on shapes is a great way to achieve the right angle on tricky foreshortening elements.

Start by drawing the sky shape

Concentrate on shape to achieve the correct angle

Outline the basic volumes

Along with seeing simple shapes, it's good to think about buildings in terms of volumes. This is a completely different way of visual thinking, one which involves feeling the three-dimensionality of the forms rather than flattening them into shapes. Constructing volumes is a powerful tool as it will help you capture the whole quickly, but in a way that makes your sketch look solid.

Tips to get you started

1 Think boxes Try to think of buildings as a series of boxes. Normally there are lots of details applied to the surface and/or overhanging elements obscuring them, but try to see through these to the underlying volumes. This is the key skill when working fast with volumes.

2 Break down volumes Most buildings are made up of different volumes – cubes, triangular prisms, cylinders, etc. Sometimes they are simply stacked on top of each other, or sitting adjacent to each other, and at other times they intersect. When you have a building made up of composite volumes, break them down mentally into their component parts first.

3 Check angles Every volume that makes up a building has various faces, and each one of these appears as a shape. So use your ability to see simple shapes to draw each side. Make sure it is the shape you actually see, not what you *think* you see! Don't even think about perspective if you are working fast; just trust the shapes.

4 See through objects Try to think of these volumes as transparent and 'see through' them to the other side. This is especially useful for intersecting volumes at the corners of buildings or when you need to align two separated parts of the one big volume. You don't have to draw the hidden lines, but being able to visualize them will give you better accuracy with speed!

5 Add and subtract Once you have the basic volumes outlined, consider all the other elements as either additive or subtractive volumes. Decorative elements are usually added to the surface of the walls, and windows and doors are subtractive, set into the depth of the wall. Drawing these elements after the base boxes makes them look more convincing and prevents you getting distracted by the details before you have sketched the whole.

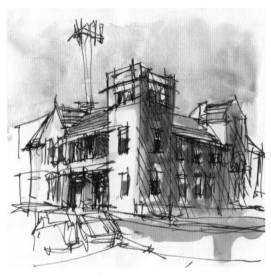

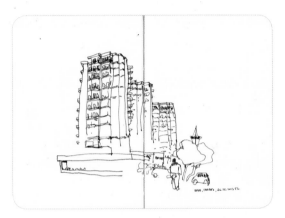

Above **Liz Steel**, *Crows Nest Fire Station, Sydney, Australia*, 2016.
I was very conscious of drawing the big boxes first: the corner element, an infill section, and then a gabled box on both sides.

Above right **Tiago Cruz**, *Ofir, Esposende, Portugal*, 2013.
Tiago has simplified a row of complex high-rise towers into rectangular boxes and indicated balconies as additive elements.

Right **Liz Steel**, *Sydney University, Sydney, Australia*, 2013.
Although a more finished sketch, the main volumes were sketched in a few minutes. Seeing the intersecting towers helped with accuracy.

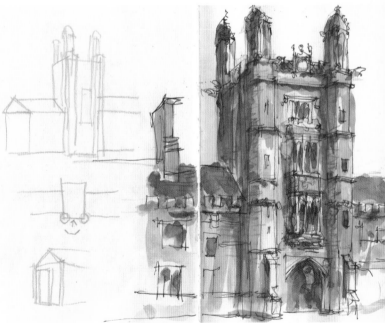

Centreline

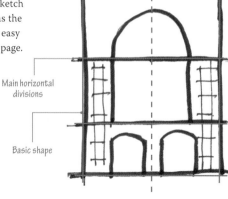

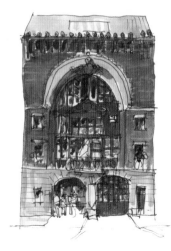

Right **Liz Steel**, *Jones Street Fire Station, New York, USA*, **2010**.
All the line work for this sketch only took a few minutes, as the overall structure was very easy to simplify and get on my page.

Main horizontal divisions

Basic shape

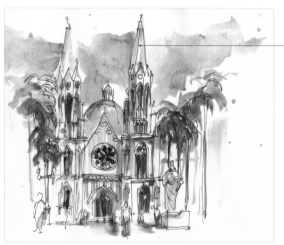

Thumbnail

Left **Liz Steel**, *Catedral da Se, Sao Paolo, Brazil*, **2014**.
A tiny thumbnail, which only took me seconds, helped me work out the major changes in plane and volumes of this cathedral.

Below **Asnee Tasna**, *Shophouse at Thalang Road, Phuket, Thailand*, **2014**.
This fun sketch starting with a shophouse stamp shows how Asnee simplified the adjacent buildings to create an impression of the whole street.

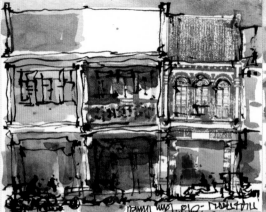

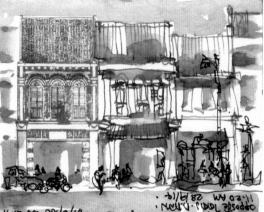

Set out the basic structure

The next step to sketching architecture, and especially complex buildings, is to work in a ordered way, starting with the major structural components. Once these are locked in during the first few minutes of your sketch, it is much easier to then add windows and details. It is also good to practise drawing front-on sketches of building façades before attempting more angled views that require perspective.

Tips to get you started

1 **Changes in plane** Begin by looking for any major changes in plane – areas that indicate a different underlying volume. Towers on either side of a cathedral front are a good example.

2 **Structure and rhythm** Look next for the major structural elements, such as columns and entablatures (horizontal bands) in classical buildings, or buttresses in gothic architecture. They create the major divisions in a building and once they are positioned, everything else will just fall into place.

3 **Storeys and bays** For large buildings, you might think that counting windows is the way to divide up the façade, but it is much quicker to count their bays and leave the windows until later. When it comes to dividing the building vertically, look for the important joints that describe the changes in storeys. Once again, it is much faster to get these on your page before you start the details.

4 **Differing widths** Look out for any storeys or bays that are wider than the others. These often occur horizontally at the ends and in the central bay. Vertically, there is often a reduction in height as the building ascends. Every building is unique, but knowing these general rules will help you quickly see the differences in width and make allowances instinctively.

5 **Centrelines for alignment** A lot of buildings have different sized windows on each storey. Drawing a centreline down the middle of the bay will make it a breeze to align all the variations in window designs! You can do this with a pencil or just a thin, dashed pen line. You won't notice it in your finished sketch.

Easy measuring

Building proportions are something that architects design very carefully, but when we are sketching fast we have to have a flexible attitude about accuracy. The key is to take a few moments with the overall measurements and then proceed on that basis. There are a lot of different approaches, but here are some speedy ones.

Tips to get you started

1 **Use your pen to measure** Sketching in proportion means that heights and widths on your page are in the same ratio as they are in your subject. Close one eye, hold your pen in front of you with a locked elbow, and use your thumb to mark on your pen the length of one part of your subject. Rotate your pen, and compare this with another part of your scene. For example, you might measure a building to be one length high by two lengths wide. You can then transfer this ratio to a length of line that suits the size of your page.

2 **Unit of measure** If you are unsure about how to start measuring your subject, use a dominant vertical as a reference point. Sometimes you can use the whole height of this vertical edge, but at other times the height of a single storey will be more helpful. Measure the most important widths using this unit of measure. To improve your speed, only measure the overall shapes and trust your eye for the rest – it will be good enough!

3 **Find squares** If you don't want to do any counting, it might be easier to simply look for squares to get the overall proportions and then do all internal divisions by eye. This is the quickest way to measure, as it's easy to see this merely with your eye, without lifting your pen.

4 **Hands of a clock** If you are drawing a building in a perspective view then you will need to measure angles as well. The quickest way to do this is to relate the angle of the building edge to the hands of a clock. This mental shift really helps you see better!

5 **Go for it** There is a real danger of getting caught up in trying to get it right. If you are using preliminary pencil lines, you might find yourself erasing them continually and getting really bogged down. So the rule of thumb is to do an initial measurement and then stick with it. Your measuring and sense of proportion will improve over time.

Below Liz Steel, *San Giorgio Maggiore, Venice, Italy,* **2010.**
I used the hands of a clock for the main lines and then made sure I adjusted heights to suit my foreshortened angled view.

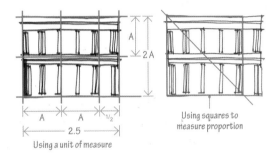

Using a unit of measure

Using squares to measure proportion

Use clock hands to measure angles

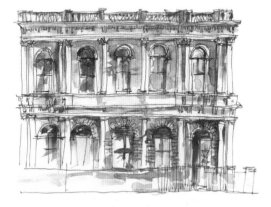

Above Liz Steel, *Tasmanian Heritage Building, Hobart, Australia,* **2014.**
The set out for this elaborate building was easy. I simplified the structure, then used the height of one storey and squares for measuring.

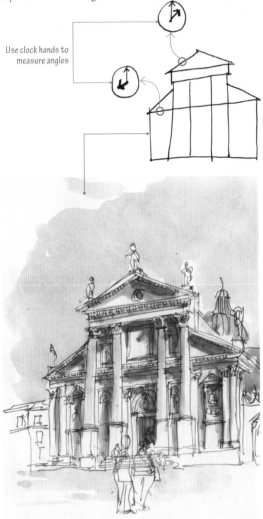

Right Liz Steel, *US National Bank, Portland, Oregon,* **2010.**
This was a very quick sketch with no physical measuring; I was just thinking about relative lengths and clock hands when I drew the first few lines.

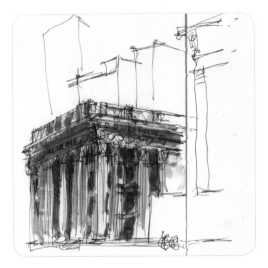

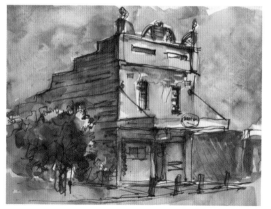

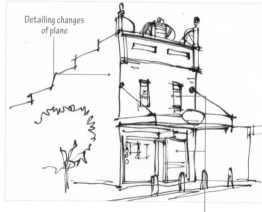

Detailing changes
of plane

Describing frames
and recesses

Above **Liz Steel**, *Sweetness Patisserie, Sydney, Australia*, 2016. Even though sketching loosely I still added extra lines to describe window frames and recesses, and the changes of plane in the brickwork.

Above **Luis Ruiz Padrón,** *Notre-Dame, Paris, France*, 2012. Luis used a clear image of the thick buttresses and deeply recessed doors of Notre-Dame to nail his initial sketch, which he then developed into this finished work.

Right **Liz Steel**, *Shophouse, Little India, Singapore*, 2015. There are lots of thicknesses in this sketch, including the red tiles and turquoise fascia board and the sides of the columns.

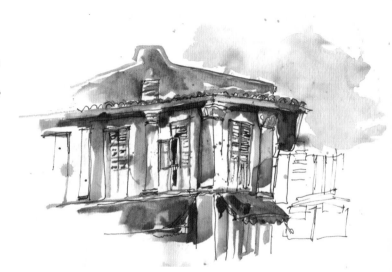

Basic thickness and depth

If you have tried to set out the basic structure and measured overall dimensions, you might still find it hard to fit everything in! A consciousness of the thickness of building elements helps you see them better, making it much easier to sketch them. Every part of a building is made up of sturdy materials that overlap and overhang – not super thin cardboard!

Tips to get you started

1 **Feel the depth of the wall** Most walls have a significant thickness – the older the building, the thicker the walls will generally be. Elements like doors and windows are set back into the depth of the wall, so look to see how much of that you can see. It is often only a matter of adding a few lines to your sketches to make them look much more realistic.

2 **Look for thicknesses** All elements of buildings have thicknesses and they are often assembled in a way that reveals their construction. For example, the edge of a roof is not normally a single line; look for fascia boards, gutters and other decorative items. Columns and cornices not only have thicknesses, but also depths extending from the wall surface. Don't merely draw a wallpaper front to the building!

3 **Leading edges** Look for the profile of a corner of the building. Running your eye quickly down and across each step in this 'leading edge' will give you a sense of the changes in planes. This will then help you allow for the appropriate thicknesses and depths when you go to pick up your pen.

4 **Thicker than you think** A general rule of thumb is that columns, entablatures and other architectural elements are thicker than you expect them to be. If in doubt, check their dimensions against the width of a window. You might be surprised!

5 **Check areas in between** You might find that it is hard to fit the windows in because there is a natural tendency to draw them much bigger than they are. To avoid this, look at the spaces of the wall surfaces in between, or the size of the glass. When it comes to windows, they are often smaller than you think!

Nail the eyeline

It is great to develop your architecture sketching skills by starting with flat front on views of buildings, but when you want to progress to more three-dimensional views, the most important tool for accurate but fast sketching is to understand the concept of the eyeline (or horizon) and position this on the page at the start.

Tips to get you started

1 **Everything is horizontal** As any object recedes in space it appears to get smaller, and any parallel edges will appear to converge at a single point on the horizon. The horizon equates to the level of your eye (the eyeline). The most important thing to grasp is that all lines are horizontal at your eyeline, so look for this effect whenever you are out and about, even if not sketching.

2 **Above go down** Any objects with parallel edges that are above the level of your eye will converge down to meet the eyeline. A great example of this is the horizontal edges of roofs. There is a natural tendency to draw the edges going up, but unless you are higher than the building and looking at it from above, these lines will go down.

3 **Below go up** A similar rule applies to parallel edges below your eye height, which will all converge up to the eyeline. The trick with edges below it is that they are often much flatter than you expect, so check to make sure that you don't draw them too steep.

4 **Hang objects from it** The concept of the eyeline really helps in structuring complex scenes. It is especially useful when you are standing up, sketching in a flat public space. Everyone's eyes will roughly align with the level of yours, so 'hang' their heads off your eyeline. You can also do this in a café where everyone is sitting in chairs at the same height.

5 **Horizontal axis** The eyeline can also be used as a horizontal axis with which you can reference other objects. Every time you look up at your scene you can compare objects against the imaginary line level with your eye.

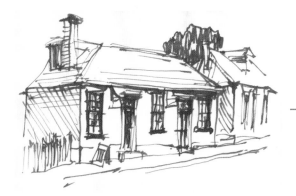
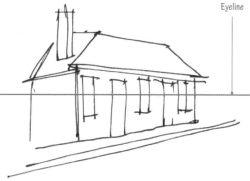

Eyeline

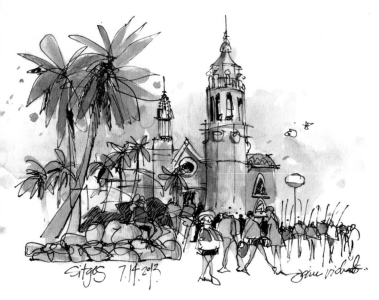

Sitges 7.14.2013

Above Liz Steel, *Battery Point Cottage, Hobart, Australia*, 2015.
Even if I don't draw the eyeline on my page, I always look for it and mentally register where it is before I start.

Left James Richards, *Paseo de la Ribera, Sitges, Spain*, 2013.
A classic example of hanging people off the eyeline. In this case, however, James has slightly adjusted the heights of the people to make the scene more dynamic.

Below Liz Steel, *Federation Square, Melbourne, Australia*, 2013.
A sloping public space is challenging! However, I used my eyeline as a horizontal axis to reference all the shapes and figures in the scene.

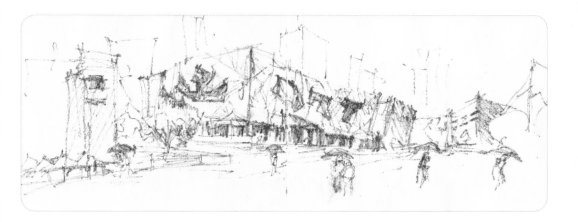

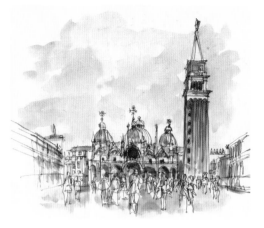

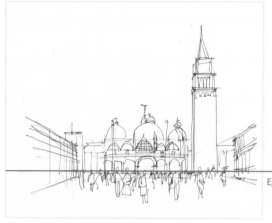

Eyel

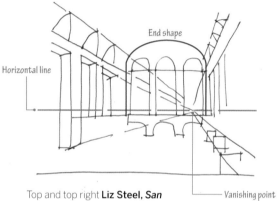

Horizontal line

End shape

Vanishing point

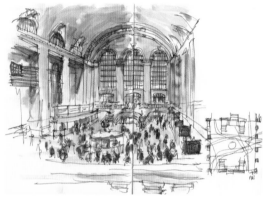

Top and top right Liz Steel, *San Marco Piazza, Venice, Italy*, 2010.
I started with a quick outline of San Marco and Campanile, then drew the eyeline and hung all the people off it.

Above and above right Liz Steel, *Grand Central Station, New York, USA*, 2010.
Although this is a complex interior sketch, the perspective set-up, shown in the diagram, was completed in a few minutes.

Right Richard Alomar, *Carrer de Colom, Barcelona, Spain*, 2013.
Single-point perspective is perfect for vistas down narrow streets. This quick sketch by Richard shows how simple it can be!

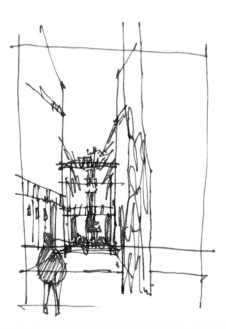

Simple one-point perspective

The best way to put together all the techniques you have explored so far is to do a simple one-point perspective sketch. This approach is great for explaining the space in front of a building, or an internal space. It is easy and, most importantly, quick to sketch.

Tips to get you started

1 **Sit straight on** The first step is to position yourself so that you are looking straight on to the front of a building, or the end wall of an internal space. It makes it easier if you start with a rectangular internal space, or a location where the surrounding buildings are perpendicular to this main façade.

2 **Establish the end shape** Determine the size and shape of the end shape and position it so you have enough room on your page in front of it for the space you want to include. You might need to make it smaller than you think in order to fit the space in front into your sketch. But that's fine, as your sketch is about space, not a detailed building portrait.

3 **Eyeline and vanishing point** Once you have drawn the outline of the end shape, establish where the eyeline is and the single vanishing point where all the converging lines meet. This point will always be on the eyeline.

4 **Project out** Project a few key lines out from this vanishing point using the skills you have developed previously – seeing the main volumes and the important horizontal edges. So that you don't get a lot of lines drawn around the vanishing point, draw in the air just above the surface of the page for the parts of the line you don't want to see, or use big dashed lines.

5 **Add depth to walls** Don't forget to add depth to the walls so that they don't look flat. The sides, tops and undersides of various architectural elements will come alive if you add the receding faces.

Rapid pointless perspective

When it comes to two-point perspective – the view you have when you sit obliquely to a building – the same principles as one-point perspective apply. Here, however, instead of starting with the end shape of the building, you start with a vertical edge. Worrying about achieving a perfect perspective set-up can slow you down, so these tips are especially designed for quick sketching!

Tips to get you started

1 **No vanishing points** A common challenge when sketching buildings in perspective is that the vanishing points are off the page. In fact, it is very rare to get both vanishing points on the page unless you sketch small. So the trick is to understand where they should be, but then focus more on drawing what you can actually see.

2 **Vertical edge** A great place to start is with the dominant vertical edge in your scene – this is often the corner of the building closest to you. Position this vertical line on your page and then use it as a reference for all the other lines. It establishes the height of the building and can be used as a measuring stick.

3 **Nail the eyeline** As with single-point perspective, you need to locate the eyeline in relation to this vertical edge. It doesn't matter which order you complete these two steps, but they establish the two important axes for your whole sketch.

4 **Important angles** Next, you need to establish the angles of the top and bottom edges of the main faces of the building using the 'hands of a clock' technique. All parallel edges must meet at the vanishing point, so if the vanishing point is off the page, just track with your eyes to check they do meet. Don't forget to continue looking for shapes as well, as this will help you see angles more accurately.

5 **Converging grid** Once the top and bottom edges are established, all you need to do is draw a grid of evenly converging lines between them. Don't worry about perspective rules; just look at the lines on your page and see if they are fanning out equally from the eyeline.

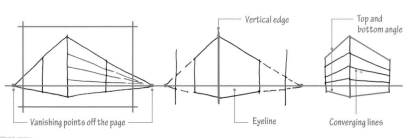

Vertical edge

Top and bottom angle

Vanishing points off the page

Eyeline

Converging lines

Pointless perspective diagram.
The four steps for pointless perspective: a vertical edge, the eyeline, top and bottom angles, and then a grid of converging lines.

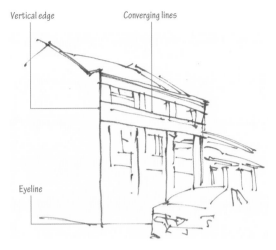

Vertical edge Converging lines

Eyeline

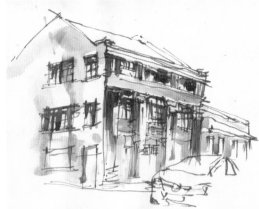

Above **Liz Steel,** *The Substation,*
Civic, Singapore, **2015.**
After starting with the front vertical
edge and an eyeline close to the
ground, I quickly drew a series
of evenly converging lines.

Below **Suhita Shirodkar,** *Basilica*
of Bom Jesus, Goa, India, **2015.**
Suhita sketched this with a great
sense of perspective and the eyeline,
and added receding faces on the front
façade, bringing the building to life.

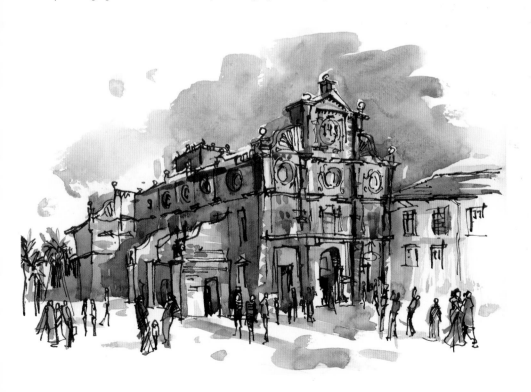

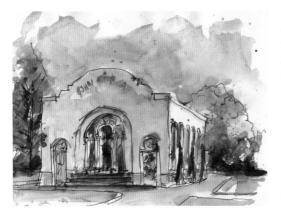

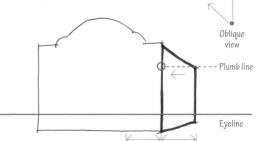

Left and below **Liz Steel,** *City Park Glasshouse, Launceston, Australia,* 2015.
I used a horizontal plumb line to check the length and angle of the side wall, which, is much longer than the front face.

Oblique view

Plumb line

Eyeline

Foreshortened side wall

Right **Liz Steel,** *Corner Shop, Surry Hills, Australia,* 2014.
Although I didn't carefully form the windows on the two sides of the building, I was very conscious of their foreshortening.

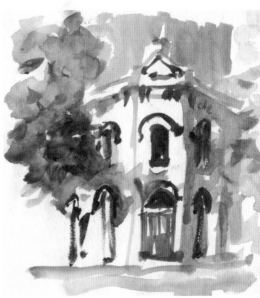

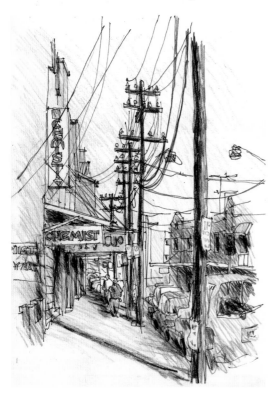

Left **Peter Rush,** *Illawarra Road, Marrickville, Australia,* 2014.
The foreshortening in this view is extreme. The receding length of the first shop is the same width as the narrow overhead 'Chemist' sign!

Quick tips for foreshortening

As soon as you start drawing buildings in perspective, you will notice that you are often thinking about how long a building is in reality and not focusing on the length that you can actually see. As a result, your sketch will look a bit flat because the sides of the building haven't been foreshortened enough.

Tips to get you started

1 **Shorter than you think** As a general rule, the receding faces of buildings will be shorter than you think. If it's a square building in reality and you know that both sides are in fact equal, look for the differences in length from your position. Most times one side will be shorter!

2 **Trust the measurements** When you take some measurements for the shorter side of a building and then transfer it to your page, it will often seem wrong. But you have to trust what you measure. Holding your pen up and tracing around the shapes in the air can help you see how short the foreshortened side is.

3 **Use horizontal plumb lines** A great way to cross check what the relationships of a foreshortened shape are is to use plumb lines that are horizontal. Check the height of the far edge of the side wall against the vertical edge that you are using for reference.

4 **Gable ends** Look out for gable ends on roofs or arches on a foreshortened wall. The triangular or semicircular shape will not be regular – the front half of the shape will be longer than the rear half, which recedes into space.

5 **See wall thicknesses** When you look at a wall opening from an angle, you will see into its depth. This is particularly the case with windows. Make sure you check how much of the window you can actually see; often you will see more wall than window. Don't forget that wall openings will get progressively smaller as they recede in space, until all you can see is a single line.

Play with distortion

Once you've got the hang of the basics of perspective, you can
loosen up and play with the rules a little – even bend (or curve) them!
It's very liberating to sketch with a little distortion, and it can
make it much quicker to sketch a complex scene.

Tips to get you started

1 **Distort the angles** If you get the main angles
going in the right direction (i.e. edges above
going down to the eyeline), then it is amazing
how much you can distort the angles and make
them more extreme without the sketch starting
to look 'wrong'.

2 **Curvilinear perspective** To do this, sit straight
on to a building, or a street scene, and distort
the horizontal edges so that they curve up and
down to the eyeline. You might also want to
curve the verticals. Your skills of drawing evenly
converging grids will help, but this time the lines
are to be evenly curving!

3 **Looking up** If you sit close to the front of a
building and look up, all the vertical edges of the
building will appear to taper. Due to the laws of
perspective, these will all converge at a
vanishing point up in the sky. This will probably
be off the page, so use the same pointless
approach: get the outside lines set first, and
then create an evenly converging grid in
between them.

4 **Three-point perspective** If you want to really
challenge yourself, you can combine two-point
perspective with one point looking up and get
three-point perspective. Once again, a very
quick initial set-up of the main volumes makes
this approach easier – truly!

5 **Craziness!** Throw caution to the wind and just
play with the edges in a completely random
way. As long you allow for thickness and depth,
your building will look surprisingly convincing,
but it will at the same time morph into a living
creature. It's the added dynamism created by
the distortion that brings a little magic.

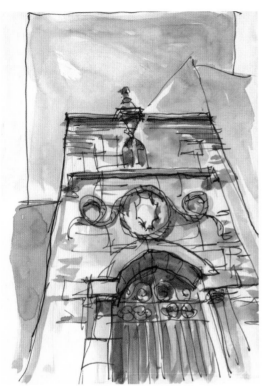

Left **Liz Steel,** *Monasterio de San Francisco, Santo Domingo, Dominican Republic,* 2012.
Once I had drawn the outside lines tapering in, the rest was easy. I included the undersides of the elements that I could see looking up.

Below **Inma Serrano,** *Chile Pavilion from Ibero-American Exhibition, 1929, Seville, Spain,* 2014.
When Inma sketches buildings, she likes to think of them as monsters, with the windows and doors being their facial features.

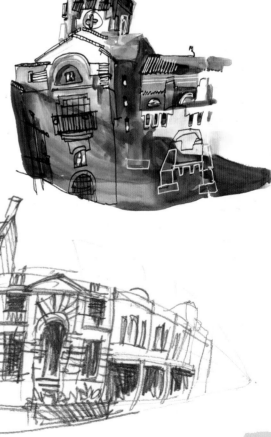

Below **Liz Steel,** *George Street, Sydney, Australia,* 2016.
I quickly drew a few curved guidelines on either side of my eyeline and then started drawing all the buildings with curved verticals.

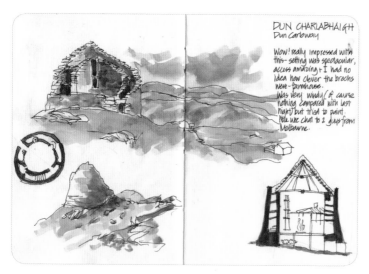

DUN CHARLABHAIGH
Dun Carloway

Wow! really impressed with this - setting was spectacular, access amazing + I had no idea how clever the brochs were - farmhouse.
Was very windy (of course nothing compared with last night) but tried to paint.
Note wee chat to 2 guys from Melbourne.

Above Liz Steel, *Dun Carloway Broch, Isle of Lewis, Scotland,* **2010.**
I wanted to capture the details of the approach to the structure (smaller sketch), and its outlook (larger sketch), using cooler colours and softer edges for the background.

Below **Liz Steel,** *St. Barnabas, New York, USA,* **2012.**
On a very wet day, I contrasted the solidity of the massive church with the rush of yellow cabs and umbrellas crossing the street in front of it.

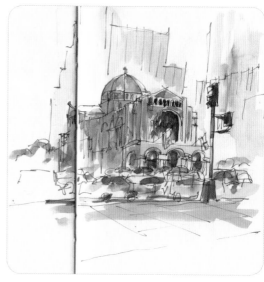

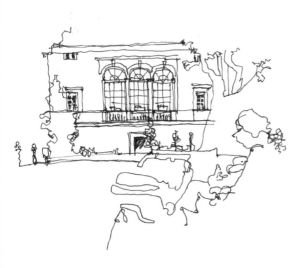

Left **Carol Hsiung,** *Vail Mansion, Morristown, New Jersey,* **2015.**
Carol let her lines weave in and out while simplifying the foreground and giving a great sense of depth between her and the background building.

Simple context

When you're trying to sketch in a limited time frame, you have to be very strategic about how much context to include. It's very important to include something of the surroundings of a building so it's anchored to a real place and not floating in space, but it doesn't need to be elaborate. It can take just a few lines to tell this story; less is more.

Tips to get you started

1 **Foregrounds for scale** Including some detail about what is in front of a building puts the whole structure into context. It can be people, cars, street furniture, trees or ground surfaces, and it only has to be a hint or an outline. These features are often unique to a small geographic area, and so will really tie your sketch to an exact location.

2 **Scale vs. depth** Drawing people beside a building gives an indication of its scale, but drawing them in the space between you and your subject creates a sense of depth. People close to you will be a lot larger than those in the distance. Spend a few moments looking at the size and location of their heads in relation to the building or your eyeline.

3 **Solid or transparent objects** You might want to capture people first and then fill in the gaps with the buildings – less to draw! But it's also fine to draw people last (as transparent objects on top of the building) giving a sense of

movement in contrast to the solidity of the architecture. Similarly, trees can be treated as solid or transparent objects, depending on how important they are to your story.

4 **Avoid detail distraction!** If you are trying to sketch quickly, make sure you don't get distracted by details of supporting elements, especially those in the background. Just keep telling yourself to keep it simple!

5 **Cooler and softer backgrounds** When adding backgrounds, use cooler colours and softer edges. The latter can be achieved with thinner or broken lines, or no lines at all. Just using paint in the background can be very effective, but if it looks too unfinished, add a few light lines to tie it back to the main focus.

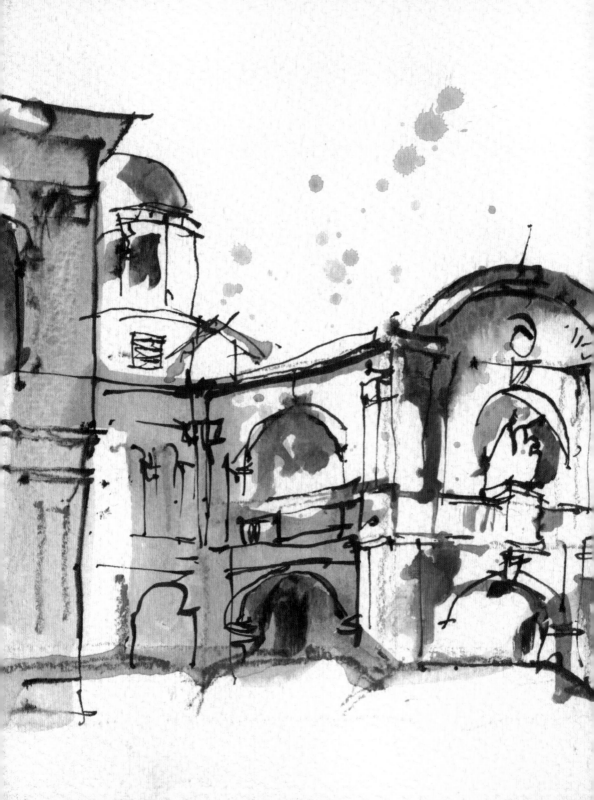

Quick on the draw

There is a huge variety in architectural subjects that you might choose to draw – from a single window to the skyline of a big city. The key to approaching both, whether the smaller architectural elements or a larger building type, is to focus on your story. The clearer you are about the centre of interest of your building or scene, the more you'll be able to reduce the scope of what you draw, making it easier to say more with less. This chapter contains a few ideas to get you thinking about unique features of different building types, and also ways to tackle them with lines, shapes and volumes.

Left **Liz Steel,** *Singapore Art Museum, Singapore,* **2015.**
Even though I was working loosely, it was still important that I captured the strong volumes and the crisp, classical details.

Focus on doors and windows

Sketching just a door or a window might seem like an easy option, as opposed to attempting a whole building. By limiting your efforts to a more achievable subject, you might be more likely to start when pushed for time, and anything that gets you sketching is good! The key is to include some context so you capture more of the big picture.

Tips to get you started

1 **Tell the story of the locals** Windows and doors are the apertures through which the inside and outside are connected. We get a different story about what happens inside and connect with the inhabitants in a different way depending on whether the door and windows are open or closed. Does the window or door tell you anything about the culture or history of the place?

2 **Entourage** Are there any supporting elements – 'entourage' – that locate the sketch in a specific place? Window shutters, window boxes, signage, letterboxes, bicycles and other objects are often unique to the locality. Include people walking past or interacting with the window or door.

3 **Surrounding wall** Don't just sketch the door or window on its own; include the wall that it exists within. How much detail you include depends on how much time you have, but look out for contrasts such as rough vs. soft texture, natural materials vs. painted surfaces.

4 **Depth of recess** A really important characteristic of doors and windows is how far back they are set into the surrounding wall (how deep the window recess is). If you are drawing the window straight on, you might not be able to see much of it, but it will often cast a shadow that will indicate this depth.

5 **Details** Windows and doors are made up of various elements – a series of frames inside the wall opening and around the panes of glass. Draw them all and notice how much smaller the glass is than you thought it was. Don't forget to include reflections in the glass, but simplify them to big areas of light and dark. Have fun adding decorative details that express both age and culture!

Recording the depth
of windows and columns

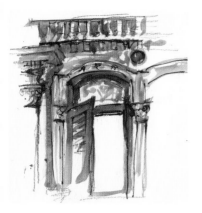

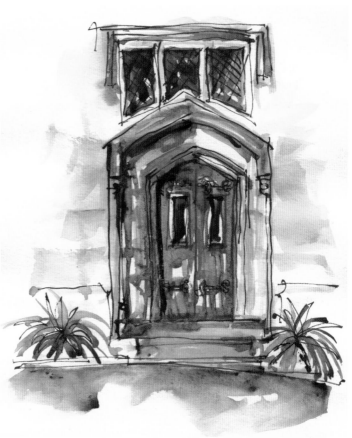

Above Liz Steel, *Shophouse window,
Kampong Glam, Singapore*, 2014.
I sketched this detail to explain
the elaborate details of a typical
shophouse, recording the depth of
the window and applied decorations.

**Above right Liz Steel,
*St. Andrews Cathedral,
Sydney, Australia*, 2014.**
In this straight-on sketch I wanted to
capture the depth of the wall opening
and contrast the painted blue door
with the sandstone wall.

Right Isabell Seidel, *Mata-lo Bicho,
Ourense, Spain*, 2013.
The doors are an integral part of this
scene, and Isabell gives us just enough
detail for us to be able to see a much
bigger picture.

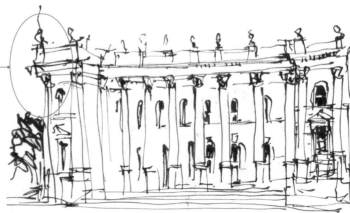

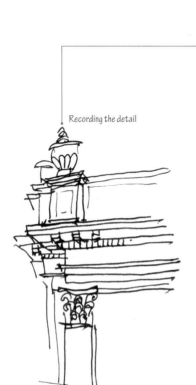

Recording the detail

Above and left **Liz Steel, *Launceston Town Hall, Tasmania, Australia*, 2015.**
The ability to sketch this building in only a few minutes was completely dependent on my knowledge of what the details are like up close.

Below **Liz Steel, *Angkor Wat, Angkor, Cambodia*, 2015.**
On a big scale, I used the leading edges of the stepping forms to distinguish between different elements and then just hinted at everything else.

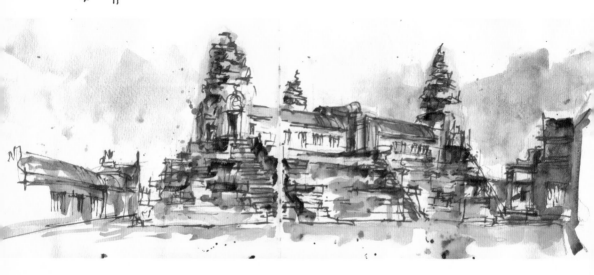

Simplify details and styles

Many historical buildings have lots of elaborate details that can initially be a little overwhelming. But if you look for the main structural elements first, you will see a much more manageable pattern to describe. There are also some key features of classical and gothic buildings which, once you understand them, will help you draw any building related to that style much more quickly.

Tips to get you started

1 **Leading edges** Drawing the leading edge first – a corner that reveals the building's profile – will give you a better feel for the ins and outs of applied decorative elements and take the pressure off drawing the right number of lines across the façade. In addition, look for the part of a decorative feature, such as a cornice, that protrudes the most, and draw that first, filling in the lesser lines later.

2 **Walk up close** Rather than guessing at what you are drawing, walk up close and look at the detail, then walk back and see what parts are visible if you squint. The close inspection will inform your lines even though they are loose.

3 **Repetitive and geometric patterns** If there are some highly decorative details, look for a repeating pattern and/or the geometric structure underneath the complexity of curved elements. Drawing this structure, just as you do for the main building, makes it easier and prevents random scribbles!

4 **Don't draw it all** Once you have seen this geometric pattern you can fade the amount of detail as you move away from the focal point in your sketch. This is a great way to share your discoveries about the building design with the viewers of your sketch, and one of the most critical strategies for sketching fast.

5 **Develop your shorthand** As you get to know a architectural styles better, you will develop your own way of simplifying them at different scales – a personal shorthand. For example, a Corinthian column can be simplified into shapes for the capital and three tiers of little marks representing the detail of the acanthus leaves.

Have fun with walls

We are all drawn to the texture of a wall – especially when it is old and made up of natural materials such as stone, timber or earth. We notice whether it is rough or smooth, has a random or regular pattern, is dense and heavy or light and reflective. But it is easy to get caught up in an unnecessarily detailed rendering of these textures.

Tips to get you started

1 How much texture? Think about the characteristics of the wall and how important they are to your story about the building or scene. It is natural to have a desire to record them, but if they are secondary to the main focus of your sketch, try to restrain yourself.

2 How dominant are the joints? Squint to see how strong they are in the big picture. Think about their size and contrast in relation to the bricks, blocks or panels. Joints that create a change in plane will normally be more dominant as they cast a shadow on the surface on the wall. These are the joints you might want to focus on.

3 Pencil, pen or paint? Once you've worked out what is important in the wall texture and joints, you can make a more informed decision as to how to render them. In order of strength, you can use pen, pencil, coloured pencil, watercolour pencil (which will slightly dissolve) or simply varied brush strokes with no lines.

4 Big wash with gaps By loading up your paintbrush with a juicy watercolour wash and varying your brush strokes, you can indicate texture and joints without much effort. This is the best tip for speed!

5 Vary treatment You don't have to use the same treatment for the whole sketch. You can concentrate the detail at your focal point and fade it as you work away from it. Alternatively, switch between different rendering techniques, with the most dominant one closest to your focal point.

Wall texture

A few ways to create textures for walls: with watercolour pencil, with ink and wash, or simply with your brush strokes.

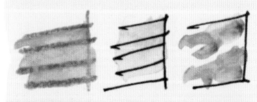

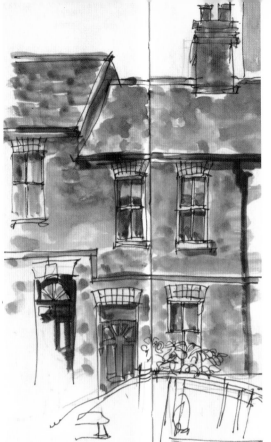

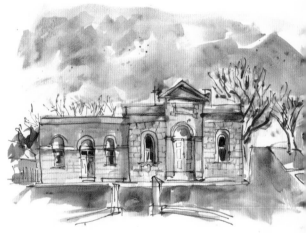

Below **Liz Steel**, *Ross Town Hall, Tasmania, Australia*, **2014**.
There were three different types of sandstone blocks in this building, so I used three different techniques with my pen, watercolour pencil and brush strokes.

Above **Liz Steel**, *Terrace House, London, UK*, **2010**.
In this very quick sketch I depicted the brick and tile textures simply by the way I applied my brush strokes.

Right **Delphine Priollaud-Stoclet**, *Saint-Constantin Church, Parikia, Paros Island, Greece*, **2015**.
A great example of a restrained approach to wall texture: a few lines, dabs of paint and loose light washes were all that Delphine needed.

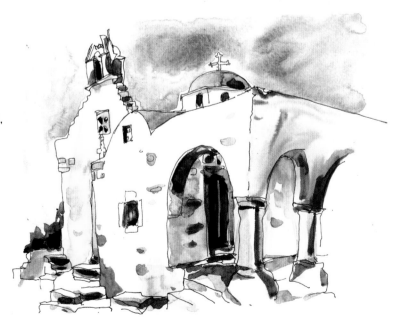

Rapid roof shapes

On some buildings the roof is a major element. It can be a symbolic representation of enclosure and security, or it can make a bold statement to draw attention to the building. Rather than drawing the roof last, sometimes it is good to start with it. This also ensures that it fits on the page!

Tips to get you started

1 **No need for perspective** With lots of different angled planes that make up different roof forms, it is often too tedious to set up multiple vanishing points. So don't even waste time thinking about it! Instead, just look for the horizontal edges, such as ridge lines and the bottom edges, and incorporate these into your grid of converging lines.

2 **Look for shapes** A quicker and easier way is to squint and see the roof as one shape. You will be surprised how accurate a method it is, even when the roof is really complex or irregular.

3 **Different colours for different faces** To give three-dimensionality to your roof form, vary the colour and/or tone of the different faces, responding to the amount of light each is receiving. You might even consider leaving those faces that are receiving direct sunlight as pure white.

4 **Texture** Look for the dominant direction in the pattern of the roof material. For example, draw the pattern of tiled roofs as either horizontal or vertical, depending on which has the greater change in plane, but don't draw the lesser lines

between the individual tiles. Also, consider the scale of the texture and whether adding lines will add to the visual weight of the roof.

5 **Thickness at the edges** Don't forget the thickness of the roof at the edges! Most roofs have fascia boards at the ends of the roof rafters, often with gutters attached. And don't miss the downpipes either, as they often add a lot of character to the building.

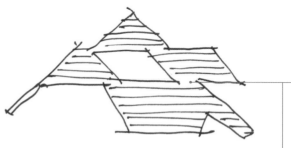

Above and opposite **Liz Steel, *Local house, Sydney, Australia*, 2015.**
I simplified a very complicated roof into the one shape and then varied the intensity of my watercolour wash to create a three-dimensional form.

Painting the roof as one shape

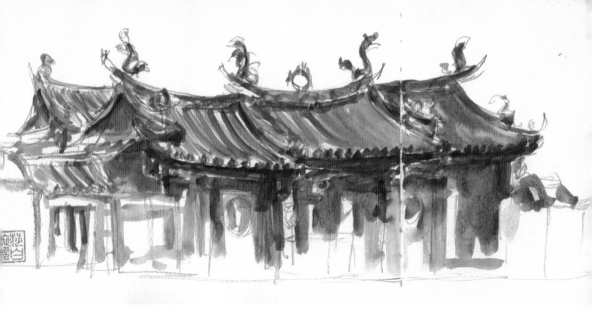

Above **Liz Steel,** *Thian Hock Keng temple, Chinatown, Singapore,* 2013.
Using a water-soluble graphite pencil, I quickly sketched the main shapes of these elaborate roofs in a few minutes, feeling the curvature of the forms.

Right **Rene Fijten,** *View from Cité administrative de la ville de Liège, Liège, Belgium,* 2014.
Rene applied a loose wash tying together a collection of roofs. Drawing the tiles would have taken time, but the overall shape was captured quickly.

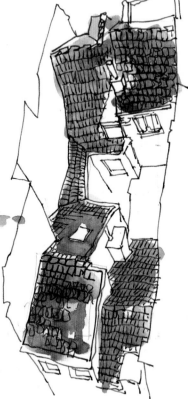

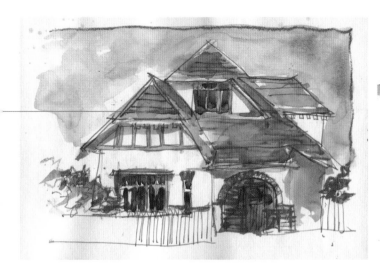

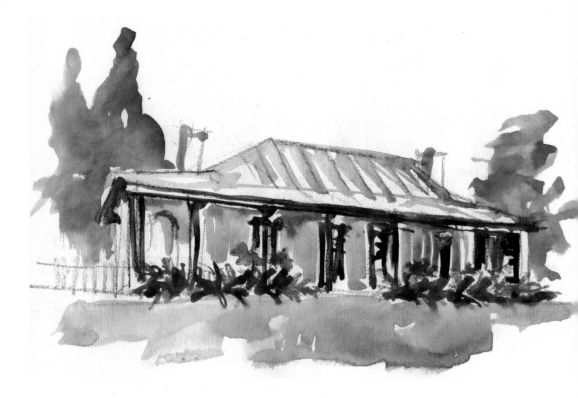

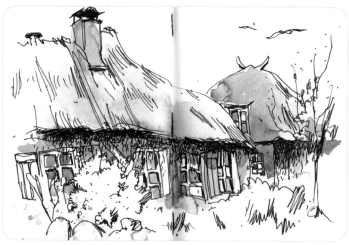

Above **Liz Steel**, *Hambledon Cottage, Parramatta, Australia*, 2014.
This is an early Australian building with a corrugated iron roof and wrap-around veranda, which established a strong vernacular.

Left **Isabell Seidel**, *Fisherman's Village, Gothmund, Germany*, 2015.
Isabell used a restrained treatment of textures for these cottages, with their walls obscured by landscaping and with very distinctive thatched roofs. A very inviting scene!

Opposite **Liz Steel**, *Federation house, Sydney, Australia*, 2016.
Although a quick sketch, I hinted at all the details in the brickwork, windows and roof, since it is important for this style of house.

Simple houses

The detached single dwelling house has universal appeal. It's everyone's image of home, symbolic of family, warmth and security. Each locality has distinctive housing designs reflecting the culture, climate, local materials and changing tastes over the years. When sketching houses, it is important to keep in mind all these factors and let them inform your story. It must look like a home!

Tips to get you started

1 **Roof first, walls second** As the roof is often a dominant feature, start drawing it first. It is then simply a matter of projecting the walls down. Often there is also a lot of landscaping obscuring some of the walls, so you might not see much at all. It's all about the roof, the chimneys and the garden!

2 **Local materials** The standard house design in any area reflects the readily available materials, often resulting in a unique wall and roof combination. Look for this feature, as it connects your sketch to the locality.

3 **Fancy doors and windows** The entrance door is a very important feature in a home and often has elaborate details. Windows from different eras can have highly decorative features, and the window furnishings (inside or out) can be important to the inhabitants. Although you might not want to render these details precisely, always hint at them.

4 **The private realm** You don't have to spend a lot of time sketching the house itself. Sometimes the most compelling story about a home is the way people separate themselves from the outside world. You might just sketch the fence, gate and landscaping, and only hint at the built structure behind.

5 **Personal touches** It is a natural response to personalize the place where you live, so look for these identifiers of the individuality of the owners. This is especially interesting in a row of repetitive houses. Perhaps the story is about the quirky add-ons and the building is merely the backdrop.

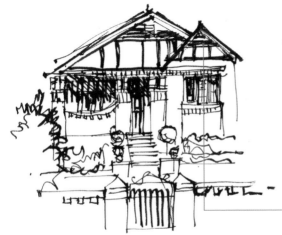

Hint at the details of the important styles

Capture historic buildings

Whenever we go to a new city, we are interested in discovering its oldest buildings. They can be either crumbling ruins, monuments to an era of grandeur or somewhere in between. But regardless of how impressive they are, it is the story of the early inhabitants of a place that interests us. Capturing the essence of a previous generation through the built environment is the key to sketching historic buildings.

Tips to get you started

1 **History** You might not live in a place with a long history but, no matter where you are, look for the oldest buildings and think about the people who built them. Were they just trying to survive, building what they could with the materials at hand? Or were they trying to impress? Let these thoughts inform your sketch.

2 **Context** Significant historic buildings were often strategically placed within a city, such as sitting at the end of an important axis, or fronting a major public space. Are you able to see if this changed over the years? Include the context of the building that you are drawing and how the modern city interacts with it.

3 **Materials** In our day and age, architects and developers can use any materials they like, but former generations were much more limited in their choices. Was the historic building built with local materials, and how do they contrast with the modern shiny surfaces? Are the marks of the people who built the building visible? Consider zooming in and telling the story of the human touch.

4 **Contrast** Not only is there a contrast in the materials between the old and the new, but the scale is often radically different. Make sure that you carefully observe the sizes of both, and think about how your use of line and colour supports the contrast. Perhaps the modern buildings will not need much detail.

5 **Style indicators** As we have seen in the first chapter ('Set out the basic structure', page 20), looking for the main structural elements is an important way to sketch a building quickly. It also helps to recognize a few architectural style characteristics. For example, when drawing classical buildings, look for the columns and the horizontal bands they support (the entablature). Refer to 'Key architectural elements' on page 8 for some of the major style indicators.

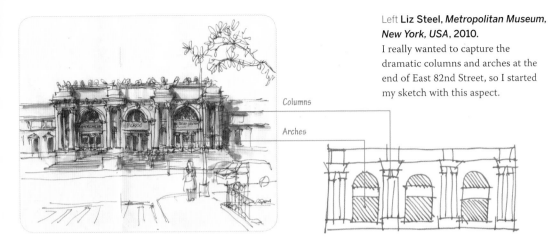

Liz Steel, *Metropolitan Museum, New York, USA*, 2010.
I really wanted to capture the dramatic columns and arches at the end of East 82nd Street, so I started my sketch with this aspect.

Columns

Arches

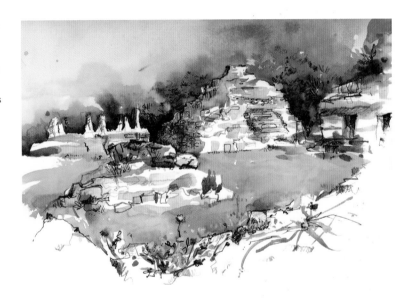

Right Suhita Shirodkar, *El Rey Ruins, Cancun, Mexico*, 2016.
By focusing on the shapes and spaces and not so much on the stonework, Suhita has created a feeling of the grandeur of this ancient city.

Below Liz Steel, *Cadman's Cottage, Sydney, Australia*, 2016.
By limiting my use of line and colour, my sketch shows the change in scale of the modern city from Australia's earliest residential building.

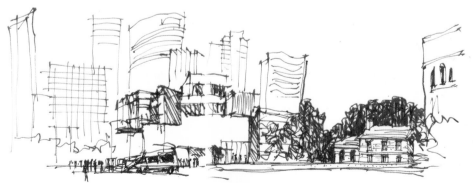

Right **Asnee Tasna,** *Golden Mount, Bangkok, Thailand,* 2016.
Asnee zoomed in to the central feature of this large structure, started with a few big shapes and then added details in an exploratory way.

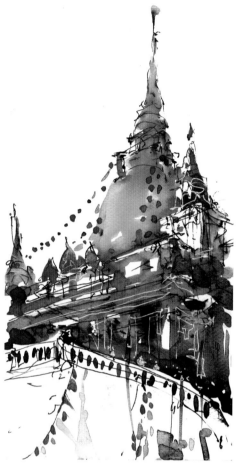

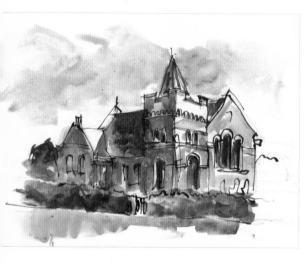

Above **Liz Steel,** *St. Mary's Church, Kempton, Australia,* 2014.
I started this sketch with shapes for the main volumes, which are very prominent in this building, and then added details over the top.

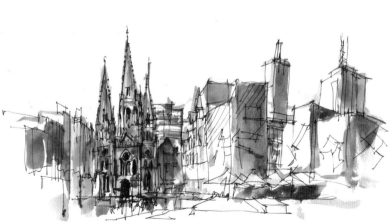

Left **Liz Steel,** *St. Paul's Cathedral, Melbourne, Australia,* 2016.
This cathedral has a strong presence in the city, so I limited the details of the surrounding skyscrapers.

Easy religious buildings

Arguably, the most significant buildings in any locality are the places of religious gatherings. They say so much about the beliefs and customs of the local people. Each religion gives different significance to the outward structures – from Buddhist stupas, where the focus is on the activity that occurs around them, to small, simple Christian churches that might not have any outside adornment, because all the significance occurs within.

Tips to get you started

1 **Drawing attention** Most religious buildings are built to draw attention to themselves as a meeting place for worship. They might be on a massive scale, have a tall tower with a bell at the top or feature a huge dome enclosing a space for the masses. At street level the entrance is often grand, even cavernous, drawing you in. Make sure that you sketch the aspect of the building that you notice first.

2 **Underlying volumes** Because the parts of a church or temple have distinct functions, they are often described by different architectural forms – the main body (nave), secondary chapels, towers, porches and so on. As a result, looking for the underlying volumes (see 'Outline the basic volumes', page 18) is often the quickest way to draw the overall building.

3 **Symbolic elements** Even if you don't know anything about the religious liturgy and customs of the building, look for symbolic and repetitive elements. Once you have the main volumes drawn, it will be much easier to add these decorations over the top.

4 **Look for human interaction** Is there any way in which the people of the city interact with the customs of the building? Are they selling goods to be used in the religious ceremonies? These supporting functions and activities might be a more interesting story for you than the elaborate structure behind them – in which case, just hint at the building in the background.

5 **Exploratory drawing** Don't try to capture it all. Just start at one point, perhaps the top of the building or one of the important symbolic features (the part that is shouting for attention), and expand your sketch outwards from that part.

Quick modern buildings

However you define 'modern' structures (a specific architectural style of the early 1900s or something built recently), there is a distinct difference from the historic buildings we were considering in the first part of this chapter. The essence of modern is that it is new, contemporary and often striving to be 'cutting edge'. This means that something that was radical at the time it was built can now be dated!

Tips to get you started

1 **Simple volumes** As a general rule, many modern buildings have strong, simple geometric forms. Sometimes the overall forms are very distinctive and the silhouettes make them instantly recognizable. And at other times they are very ordinary – a simple box! But don't be fooled by the simplicity, as sometimes there are subtle angle adjustments.

2 **Connection with the city** Not only is the form of the building often dramatic, but the way it connects to its surroundings can be bold as well. Often there is a drastic change in scale, use of sculptural elements, large overhangs, huge transparent walls, and a blurred distinction between the inside and outside. Sometimes, recording this connection is all you need to draw.

3 **Innovative materials** A very important part of being cutting edge is using innovative building materials. This is often the case in simple box-like buildings, so, rather than dismissing them as boring, look closer at their surfaces and see what the 'skin' or cladding is doing.

4 **Geometric patterns** Rather than the applied decorations you would find on an historic building, there are often geometric patterns caused by the structure or the cladding. As we saw earlier ('Simplify details and styles', page 42), look for the overall pattern first in order to simplify it.

5 **Texture** An innovative building skin from a few decades ago might have aged in an interesting way. The concrete of many modern buildings now has wonderful stains and discolouration. It might not be as appealing as the beautiful stone of an historic building, but it's still lots of fun to paint!

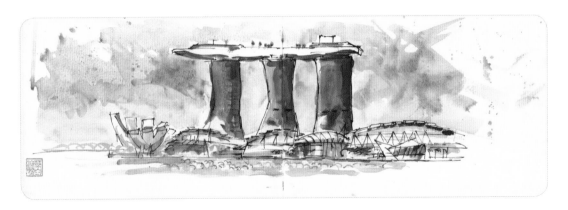

Above **Liz Steel, *Marina Bay Sands, Marina Bay, Singapore*, 2013.**
This building is so dramatic that its profile was easy to sketch! I then suggested the main edges of the sculptural structures along the water's edge.

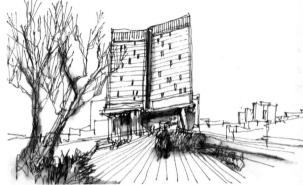

Above **Peter Andrews, *The High Line, New York, USA*, 2012.**
The subtle angles, the window patterns, the way the central building straddles the High Line – all are clearly described in Peter's simple sketch.

Left **Liz Steel, *Former CBC Bank, Sydney, Australia*, 2016.**
I always have fun sketching the volumes and texture of this landmark Brutalist building.

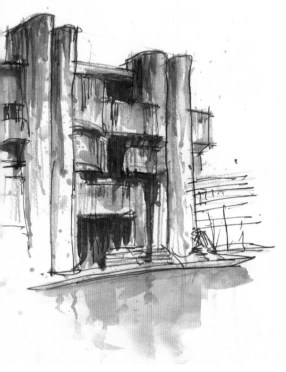

Below **Luis Aparicio,**
Centre City Buildings,
Philadelphia, Pensylvania, 2016.
Looking out his office window, Luis
simply drew the profiles with pen and
then, with a marker, shaded one side
and indicated each storey. Too easy!

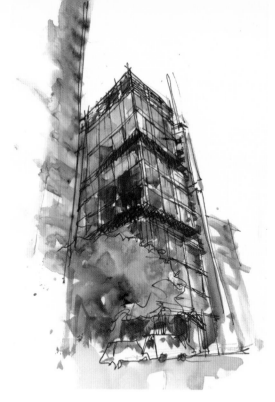

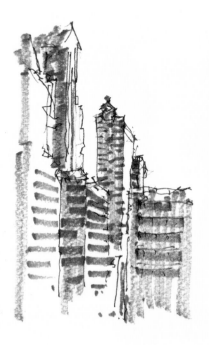

Above **Liz Steel,** *452*
Flinders Lane, Melbourne,
Australia, 2016.
From my close position,
the building profile was
greatly distorted, but I just
drew what I saw and then
simplified the solid and
glass areas.

Below **Liz Steel,**
Shophouses, Clarke Quay,
Singapore, 2013.
I wanted to contrast the
enormous jump in scale
from the small shophouses
along the river to the new,
cold, slick modern city
towering above.

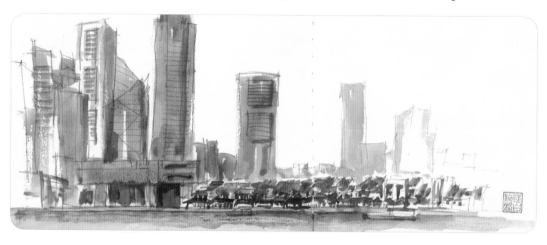

Rapid tall structures

You might think that skyscrapers are hard subjects to sketch, requiring complex three-point perspective and far too many windows to be able to draw them quickly. But with a few simple strategies, they become much easier, once again using the skills we developed in Chapter 1.

Tips to get you started

1 **Up close or from a distance** The first thing to decide is your location in relation to the building. If you are up close, you will have fun with distortion and extreme perspective, creating a sense of the building towering above you. But if you are further back, you will want to focus more on its scale and relation to the city around it.

2 **Main profile** Regardless of which approach you take, the first step is to record the main outline. If you are up close, take notice of the angles of the sides of the building and try to abstract that as a shape. If you are further back, think about the proportion of width to height.

3 **Extreme perspective** Three-point perspective isn't really that hard – it's just a matter of adding a third layer of converging grid. After drawing the main profile, add a grid of converging lines to both faces, picking out the major lines in the building façade, such as window ledges. Are the horizontals or verticals more prominent? Draw those first. Make sure you draw the horizontals increasingly closer together as the building rises.

4 **Solid versus glass** If the building has a combination of solid and glass elements, try to draw the edges between the two first, and then only hint at panels in the glass. In a glass building, look for lines that define each storey.

5 **Sense of scale** If you are drawing from a distance, make sure you include something in the foreground to give your sketch a sense of scale – people, cars or smaller buildings. If you are looking up, make sure that you include enough horizontal lines to indicate how high each storey is.

Simple skylines

Now that you have drawn a single tall structure, it's time to tackle a whole skyline. Surprisingly, this is often easier than drawing a single building. Because you are normally at a greater distance from your subject matter, the degree of detail visible is much less. The less detail, the faster your sketch will be.

Tips to get you started

1 **Start with the sky shape** We touched on this earlier in 'Seeing simple shapes' on page 16, but drawing the sky shape really is a powerful tool when sketching skylines. Draw the profile of where the tops of the buildings meet the sky, and then project your lines downwards.

2 **Look for pattern** Once you have the profile, look for the dominant direction of the pattern on each building's façade. The goal is to create variety between buildings, so there is a degree of interpretation involved. If the building is made up of lots of individual squares, draw a grid that represents the pattern and not the isolated parts.

3 **Don't stress accuracy** When sketching such a complex scene within a limited time frame, don't worry too much about drawing each building in its exact position. Look for the iconic or landmark buildings in the composition and concentrate your efforts on them. It's OK to compress a long, flat scene in order include the important bits!

4 **Minimum palette** If you are working quickly, you won't have time to accurately represent the colour of each building, so simplify by using a limited palette. Start with blue, beige and grey, and then subtly adjust those colours to get variation. This will also make your sketch look more harmonious.

5 **Paint the shady side** An alternative to adding colour to your skyline sketch is to simply add grey to the shady side of each building. This will quickly give depth to your skyline. Refer to the examples used in 'Rapid tall structures' (page 56) as well.

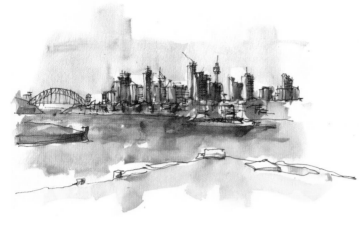

Left **Liz Steel,** *City skyline from Clarkes Point, Sydney, Australia,* 2016.
I started with the profile, compressed the view to include the bridge and then painted simple grey shapes to add depth to the buildings.

Right **Daniel Green,** *12th and Marquette skyline, Minneapolis, Minnesota, USA,* 2010.
Daniel made this skyline appear so beautifully simple by just drawing the overall profile and indicating the main pattern of the façades of each building.

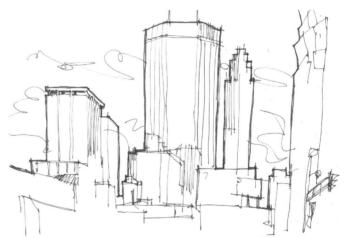

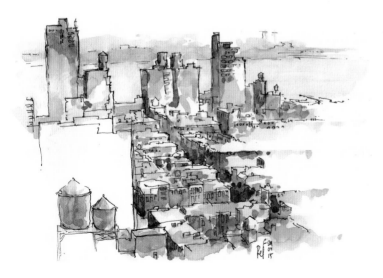

Left **Rene Fijten,** *Hell's Kitchen, New York, USA,* 2015.
Although a more finished sketch, Rene has used quick techniques, such as concentrating on the main components and only suggesting building details.

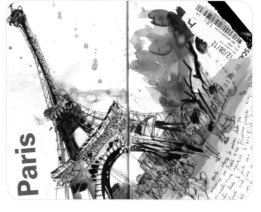

Right **Liz Steel**, *Sydney Opera House, Sydney, Australia*, **2016.** On a hot summer's afternoon, this was the only shady spot from which I could sketch this iconic building. It was great to have a new view!

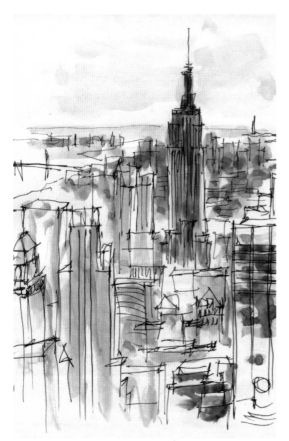

Above **Inma Serrano,** *Eiffel Tower, Paris, France*, **2012.** In this sketch, Inma distorted and bent Paris' most famous structure to create a fresh and exciting version of it.

Left **Liz Steel**, *View from the Rockefeller Centre, New York, USA*, **2010.** The moment I saw the Empire State building standing in isolation, I forgot about my intention to sketch a wide panorama and just captured it instead.

Sketch famous landmarks

Even though it is a little clichéd, you will probably want to sketch the classic icons of places you visit. Famous landmarks have the advantage of being easily recognized, so this means they are easy to simplify. But unlike the multitude of similar-looking photos taken of them every day, your sketch will be unique!

Tips to get you started

1 **Look at logos** This might seem a strange suggestion, but looking at how a complex building is reduced to a cartoon, logo or T-shirt design is a great way of understanding its basic parts. For example, think about how little of the complex structure of the Eiffel Tower needs to be drawn for it to be recognizable.

2 **Simplify but still observe** Even though you might initially refer to local tourist merchandising, make sure when you sketch that you draw from observation and make your own judgments about how to simplify landmark buildings. Don't reproduce the logo; create your own shorthand!

3 **The aspect that speaks to you** Forget what everyone says about the particular landmark. What does it say to you? Which aspect do you like the most? What is different about your current view from all the standard images? Hunt for a new view to sketch (maybe the first view you had of the building) and tell a story about that.

4 **Local connection** How do the locals interact with their landmark? Is it an important part of the life of the city, or it is totally overrun by tourists? Look for an everyday life story and bring it centre stage, simply adding a few lines in the background to position it in relation to the icon.

5 **Distort and have fun** There are no rules about literal representation. As long as you carefully observe and respond to what you see, have fun bending and distorting. Famous landmarks are very responsive to a little warping!

Capture public spaces

Big squares, wide streets, shady parks and places where people meet are the heart of the city. They are, in their very essence, busy places, and therefore complex subjects to sketch quickly. But once again, you can use the skills you developed in Chapter 1 to simplify and capture these places quickly.

Tips to get you started

1 **Space and buildings** There are two different approaches to sketching public spaces that you can use; start sketching the buildings, or begin with the people. If your focus is the space and the buildings surrounding it, draw the built environment first, then add people. It's OK to draw people over the top of any lines you drew for the buildings, as when you add colour, they won't be noticeable.

2 **People first** If your focus is more the people in the space, then start with them. This is often the quicker method of the two approaches, as it will make you realize how little of the surroundings you need to complete your story.

3 **Basic shapes** Public spaces are complex scenes, with buildings, people, trees and other urban furniture, so really focus on the big shapes, not the details. How do they interlock, and what scale are they in relation to the people who occupy the space?

4 **Only draw a small section** It's amazing how much you can say about the whole by drawing just a small portion. Vertical compositions are particularly powerful, as you can include all the important elements of a much bigger scene in a simple splice.

5 **Add details later** Let's face it, you can't always complete your sketch on location. But if you have prioritized what you started with, you can often add details later. In particular, the rows of windows in the surrounding buildings can easily be added later if you describe enough of the overall pattern initially.

Right **Liz Steel, *Times Square in the rain, New York, USA*, 2012.**
The focus was the space, the buildings and the constantly changing, colourful neon signs. People and cars were then added with loose lines and washes.

Below **Liz Steel, *Federation Square, Melbourne, Australia*, 2015.**
I started this sketch with the people in the deck chairs and then built the rest of the sketch around them.

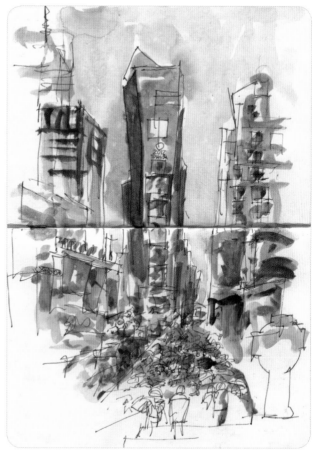

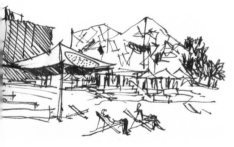

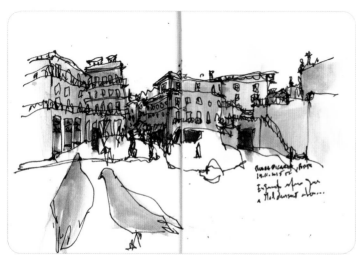

Left **Tiago Cruz, *Rua da Picaria, Porto, Portugal*, 2015.**
Tiago simplified this lively square to big shapes with loosely drawn details and then added the foreground pigeons over the top at the end.

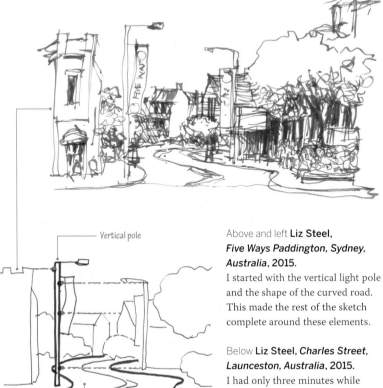

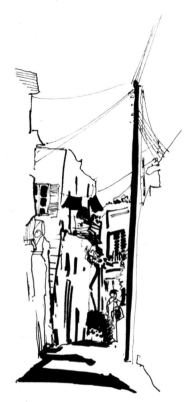

Below **Delphine Priollaud-Stoclet,** *Rue Parikia, Paros, Greece*, **2016.** Delphine has reduced this view down a narrow street into a few simple marks and some big, bold shadow shapes.

Vertical pole

Curved road

Above and left **Liz Steel,** *Five Ways Paddington, Sydney, Australia*, **2015.** I started with the vertical light pole and the shape of the curved road. This made the rest of the sketch complete around these elements.

Below **Liz Steel,** *Charles Street, Launceston, Australia*, **2015.** I had only three minutes while waiting for a friend to rapidly draw the shapes and a few details. Loose colour was added quickly later.

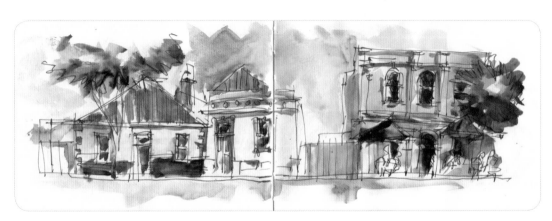

Sketch streetscapes

Streetscapes differ from public spaces in that they tell a story about a lineal collection of buildings along a thoroughfare. They can be busy with people and cars, or narrow and intimate, like the streets in historic town centres from an earlier era.

Tips to get you started

1 **Main shapes** Once again, the essence of capturing complex scenes quickly is to start with the main shapes. If you are drawing a row of buildings along a street, look for the main boxes and the different heights along the street. If you are looking down a street, notice how foreshortening causes the buildings to appear to be very narrow.

2 **Shadow shapes** It is not just the shapes of the buildings themselves that you should look for. Shadow shapes can really help you simplify your sketch and give it depth.

3 **Capture busy life** Try to include enough detail to indicate the daily life unfolding in the street. The busyness will be happening at street level, so don't get too distracted by details at the upper levels.

4 **Entourage** Make sure that you include all the supporting elements – the entourage – that make the scene busy: people and cars, but also the street furniture, the overhead wires, signage, etc. You might have to purposely draw more cars and people in your sketch than are there at any one time in order to convey the right degree of busyness.

5 **Use one pen** You might find it much easier to just use one pen to sketch a complex scene. If you use a pen with an expressive line (such as a brush pen or bent nib calligraphy pen), then you will quickly be able to add shading as well.

Simplify shops, cafés and pubs

Shops, cafés and pubs are all lively places, with lots of activity and objects to draw. Because this complexity is often concentrated in a small area, you will need to rely on a number of your five-minute sketching techniques. Once again, limiting the story you are attempting to tell is key to simplification.

Tips to get you started

1 **Inviting you in** An important characteristic of these buildings is that they desire to capture your attention and then draw you inside to buy and/or participate. So there is a big emphasis on creating an inviting atmosphere that you'll want to be part of. Make sure that your sketch has the same pull.

2 **Shop displays** Shops display goods in the window in a way that encourages passers-by to step inside, so look for the ways in which this is achieved. Start with the external treatment of the walls, windows and signage as the setting for the window displays. Then sketch the items in the windows, only hinting at what's inside.

3 **People in cafés** On the other hand, cafés are mostly about the atmosphere created by the people who are there eating, sipping coffee and chatting to their friends. The emphasis is the people, with the internal or external furniture being more of a prop, so starting with the clientele is always a good strategy.

4 **Corner pubs** Pubs and bars have a similar emphasis on people having a good time, but they are often more significant architecturally. They are normally located on street corners, with elaborate details, materials, awnings and signage. So even if you are sketching them in the morning when there is no activity, including these elements will provide a clear message about what the building is.

5 **Inside vs. outside** What is especially interesting about shops, cafés and pubs is that they depend on a strong connection between outside and inside. They each engage with the city in a distinct way, so thinking about this will help you focus your sketch.

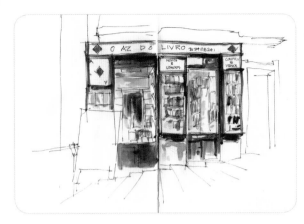

Left **Liz Steel**, *Bookshop, Lisbon, Portugal*, 2011.
I wanted to describe the distinctive shop front, bookcases and signage of this shop, and then simply hint at all the books inside.

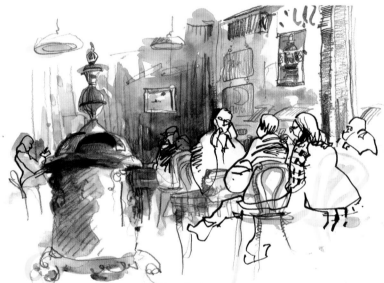

Right **Suhita Shirodkar**, *Erik's Deli Café, San Jose, California, USA*, 2016.
The people are the focus of this sketch, but Suhita has added lots of details using a variety of different media to create an inviting atmosphere.

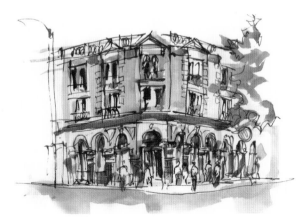

Left **Liz Steel**, *Young and Jackson, Melbourne, Australia*, 2016.
Although it was quiet at the time, I focused on the architectural features and arched doorways opening onto the street so that my sketch said 'pub'.

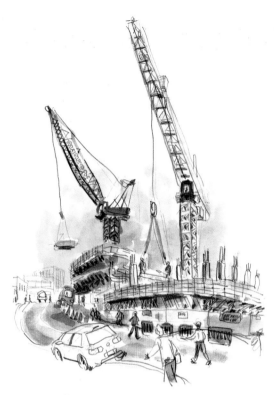

Left **Murray Dewhurst,** *Graham Street construction site, Auckland, New Zealand*, 2014.

As well as the big shapes and bright colours, the sense of the building emerging out of the scaffolding is captured perfectly by Murray.

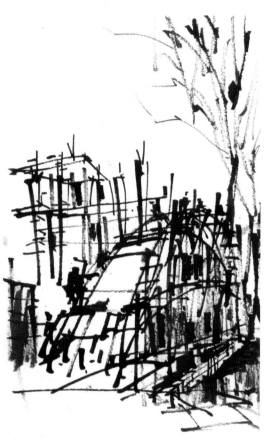

Below **Liz Steel,** *Barrangaroo from the ferry, Sydney, Australia*, 2015.

I sketched this in only a few minutes by limiting my tools to watercolour pencil, water-soluble marker and a fountain pen.

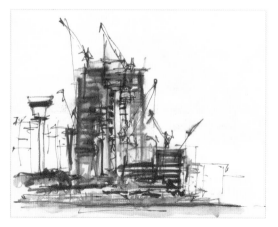

Above **Asnee Tasna,** *Construction site, Bangkok, Thailand*, 2014.

Despite Asnee's expressive strokes describing the scaffolding, we can still see the underlying structure.

Capture construction sites

You might think that architectural subjects don't ever move, but that's
not the case with construction sites. Every time you walk past, they will have
changed; cranes are constantly lifting objects and trucks are coming and going.
The temporary structures associated with construction sites make them
among the most complicated architectural scenes to draw,
but this doesn't mean they can't be sketched quickly!

Tips to get you started

1 **The building underneath** As always, it is good
to start looking for the main shapes and
volumes, but in this case, look for the building
underneath the temporary structure. The sense
of the concrete structure emerging out of the
encasing scaffolding is the essence of a
construction scene.

2 **Shapes and patterns** Don't try to work out the
structure of the scaffolding! Instead, think of it
in terms of big shapes overlaid with patterns.
Look for the predominant pattern direction and
draw that first. Simplify cranes to the overall
outline and a few diagonal lines.

3 **Add more lines later** Don't get bogged down
drawing all the lines, particularly in the
scaffolding. Just get the major components
drawn first and indicate the general patterns.
You can always add more detail later.

4 **Mixed media** Because of all the different
elements and colours on construction sites,
they are the perfect subject to explore with
mixed media. A few ideas include applying
coloured lines over the top of watercolour
washes and using water-soluble tools.

5 **Bright spot colours** One of the really fun
aspects of construction sites is the many bright
primary colours that are used for safety
purposes. So make sure that you include them
as pure colour on your sketch.

Quick-sketch bridges

The most obvious difference between bridges and everyday buildings is their emphasis on engineering and structural design. While there can be some superfluous architectural details, bridges are designed with the goal of structural efficiency. They have to span great distances and support the volume of traffic crossing them.

Tips to get you started

1 **Structure** Bridges are all about engineering, so start with the structure when you sketch. Get a sense of how far they span and where the supporting piers are, and then start with these as the first elements.

2 **Draw front faces** Many bridges have elaborate trusses, which appear as a mass of structural members. It is very important that you don't just draw a random collection of lines. Instead, look for the pattern of the front face, draw that, and then indicate some of the other major lines behind it. You don't need to draw every diagonal of a truss!

3 **Connection and context** While you don't always have to include both ends of a bridge, it is good to be conscious of the two sides that it's connecting, as this helps to put the bridge in context. How far the bridge spans is often an important aspect of its design, so include a feeling of this in your sketch.

4 **Contrasting materials** Look for different materials that have been used. Are there massive stone piers that contrast with lightweight bridge structures? How do the architectural details differ between stone and steel? Is the steel painted in a colour that is distinctive?

5 **Fade details** Once again, the key to sketching fast is not to draw it all! Water-soluble tools (pens, pencils or markers) can be used to great effect when drawing trussed bridges. Draw a few load-bearing members only, and then just add water to fade the details.

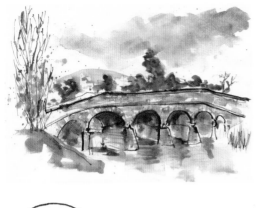

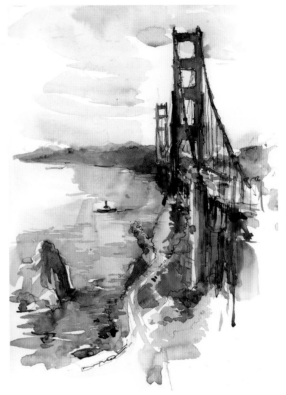

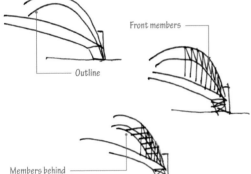

Front members

Outline

Members behind

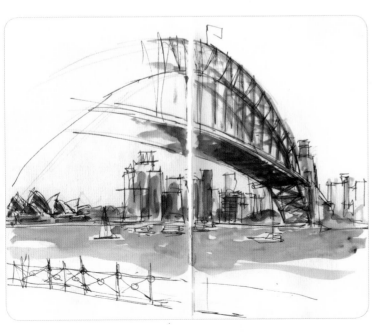

Above right **Suhita Shirodkar,**
Golden Gate Bridge, San Francisco,
California, USA, 2015.
Suhita has achieved a lovely
connection between the sides of the
bay, using loose washes and a few
lines to define the structure.

Above top **Liz Steel, _Richmond_**
Bridge, Richmond, Australia, 2014.
The main feature of this convict-built
sandstone bridge is the arches, so I
started painting those shapes first.

Left and above **Liz Steel,**
Sydney Harbour Bridge,
Sydney, Australia, 2011.
I always draw the front face of bridges
first so that the structure is correct,
and then simply hint at all the other
members behind.

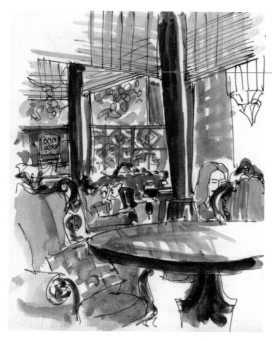

Columns used as anchors for other elements

Left **Liz Steel,** *T2 Tearoom, Sydney, Australia*, **2011.**
The columns anchored the elements in this busy interior, and enabled me to do a quick line drawing. Paint was added while I was sipping tea.

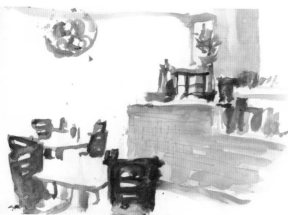

Above **Liz Steel,** *Café Nero, Sydney, Australia*, **2016.**
This quick, loose painting shows the shapes not receiving direct light from the front of the café. It was particularly fun to paint those tables!

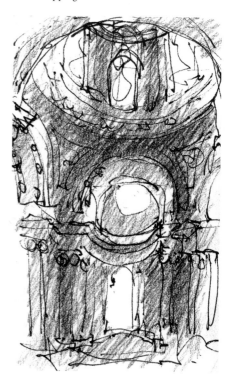

Right **Peter Rush,** *Church interior, Mexico City, Mexico*, **2012.**
Peter clearly focused on the dramatic space contained under the domes, and quickly added shading to render the light. Notice how dark some walls are.

Simple interior spaces

All the techniques that we have explored for sketching external buildings apply to sketching interiors as well. The main differences are the strong sense of enclosure, and more interesting light conditions due to multiple light sources. The important decision to make before you start sketching is whether the people or the space will be your focus.

Tips to get you started

1 **Drawing people first** Just as we explored with 'Capture public spaces' on page 62 and 'Simplify shops, cafés and pubs' on page 66, if you are most interested in what's happening inside the room, draw the people first and just indicate the surroundings.

2 **Drawing the space** Alternatively, draw the overall space as a box and then place the people or other elements within it. Sit straight on to the end wall and draw the shape of it, projecting the lines outwards, as we did with 'Simple one-point perspective' on page 28, or simply draw from observation, relating every element to its place within the box.

3 **Start with a focus** In some interior spaces, there is an element that really captures your attention. Maybe it is a central light fitting, like a chandelier, or a huge window or a piece of furniture, such as the counter in a café. Start drawing this first and work outwards from there.

4 **Vertical elements** Sometimes a big, wide interior space can be pulled together by strong vertical elements, such as a column that connects the floor to the ceiling. Alternatively, you could draw a vertical splice to explain the whole.

5 **Sketching the light** Depending on the amount of artificial light, the lighting may be very uniform and hard to simplify. However, if you are in a space with strong directional natural light, try just painting the shadow shapes.

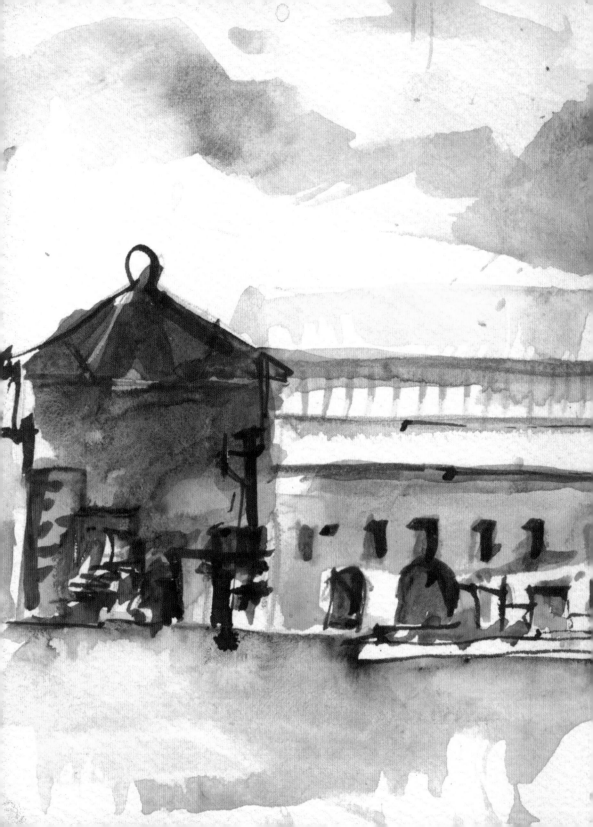

Time-saving techniques

Even though you are developing your observational skills and have got a good story to tell, you still need to make a decision about how you are going to get that onto your page with line and colour. This is when the fun really starts! A few initial considerations include what size you draw, how many lines you use and how thick your pen is. Then you will need to think about tone and colour, and how best to use them quickly in your sketch. This chapter will work progressively through ways of adding tone and colour, and then finish up with a few fun experimental approaches.

Left **Liz Steel**, *Cockatoo Island, Sydney, Australia*, **2014.**
I predominantly used shapes to describe the different forms, and added ink lines sparingly for the important elements.

Work small

One of the most powerful techniques for developing your speed sketching is to work small. The smaller you draw, the less length of line you are putting on the page, which automatically takes less time. However, there are other benefits; it forces you to simplify and prevents fiddling and overworking, making your work fresher.

Tips to get you started

1 **Look for big shapes** As we have repeatedly seen in the earlier chapters, one of the core skills to develop is simplifying the scene into big shapes. Working small forces you to do this in a way no other approach does; you physically can't fit the smaller shapes onto the page!

2 **One stroke** Another reason why working small enables you to work so quickly is that a lot of elements are reduced to a single line. At this scale, objects like windows and people can be indicated in one stroke – super fast to draw!

3 **Draw a collection** There are many occasions when you don't have time to draw a big scene, but you could easily attempt a number of smaller sketches. So start drawing thumbnails of various parts of the scene, and fill a whole page with them. This is a great technique when you are in a tour group or with friends and have to keep moving.

4 **Draw a bigger scene** On the other hand, working smaller will make a larger scene more manageable. Really focus on how objects with a similar colour or tone merge when you squint. If you get these down on the page first, you will often find that you need only a little detail to complete the sketch.

5 **Two minute sketching!** Once you have mastered sketching smaller, you will realize that you don't even need five minutes! Try to limit yourself to a lesser time frame and see how much you can achieve. You will be surprised by how much you can sketch in only two minutes. Go on – try it!

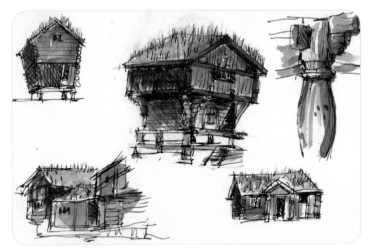

Left **Liz Steel,** *Folk Museum, Oslo, Norway*, 2009.

Doing a number of small, quick sketches was perfect for walking around this massive open-air museum with a friend.

Below **Liz Steel,** *Cockatoo Island, Sydney, Australia*, 2016.

There is no way that I could have sketched this panoramic view in five minutes if I hadn't worked small and started painting the main shapes first.

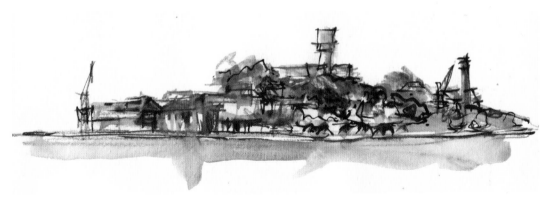

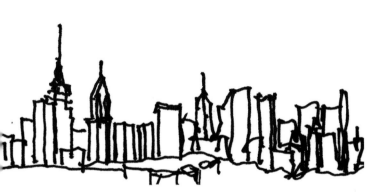

Left **Peter Andrews,** *Manhattan skyline from La Guardia Airport, New York, USA*, 2013.

The combination of the size of the sketch and the thickness of the pen helped Peter sketch this big scene in a few strokes!

Left and below **Liz Steel**, *Sydney Opera House, Sydney, Australia*, 2011.
Who needs five minutes when you can sketch a recognizable profile in seconds? Of course, with a few more minutes, you can finish it off.

Continuous line profile says it all

Fill in details if you have time

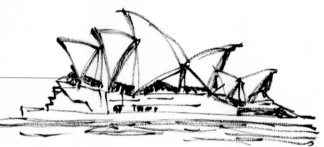

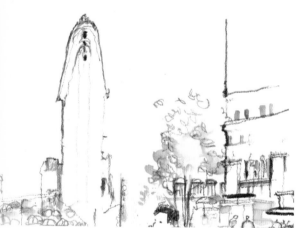

Below **Liz Steel**, *Blue Mosque, Kampong Glam, Singapore*, 2015.
By using water-soluble pencils and focusing on the major volumes, I was able to sketch this elaborate building really quickly.

Above **Carol Hsiung**, *Flatiron Building, New York, USA*, 2013.
In this striking sketch, Carol has reduced an elaborate building to a simple profile with minimal detail. Notice, too, the way she hints at its context.

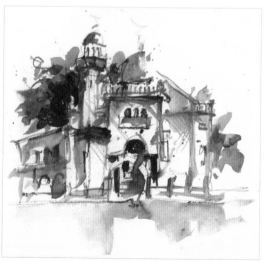

Use minimal lines

Along with working small, another great way of speeding up your sketching is to reduce the number of lines you put on the page. The more you sketch, the more you will come to realize that you don't need as many lines to describe a scene as you think you do. Being intentional and selective about every line you draw is the goal. Here are a few ideas for achieving that.

Tips to get you started

1 **Look for major volumes** Once again, looking for the major volumes and then merely drawing the edges of them will explain a sense of the whole very quickly. You can then add more details if you have a little more time, but review your sketch before you do. Are the extra details really needed?

2 **Fade out from the focus** As we explored in Chapter 2, the key feature of the particular building type you are drawing is a great place to start, and by focusing on this single aspect you can limit what you are trying to say. Be selective with your lines and only add them if they are contributing to the story.

3 **The leading edge** You don't have to draw all the edges of every volume. Just look for the leading edge – the one that is most on display – and then draw the edge of the building as it interacts with the city. Extend it to include the surroundings.

4 **Draw the outline** Simplify the building even more by only drawing its outline where it meets the sky. Many buildings have silhouettes that are very distinctive, so this single line can make it recognizable. This is particularly useful for a very complicated building.

5 **Draw only details in the light** If you want to add a few details to your profile, simply add a few to the areas that are receiving direct sunlight. Elements that are creating strong shadows, such as ledges or recessed windows or doors, are good parts to draw first.

Rapid restated lines

Unlike the previous technique of using only a few lines, this one involves working at a furious pace and drawing many lines as quickly as possible. The key is to be decisive with each line and to draw it rapidly. Each line is a single stroke (not a hairy line made up of lots of overlapping strokes) that has a distinct start and stop. This is a different style of sketching that you might like to try.

Tips to get you started

1 **Fast, decisive lines** Using a fine pen, practise drawing rapid lines, allowing them to cross at the corners, as architects do. Then start sketching with confident lines, relying heavily on your instinctive eye-hand coordination.

2 **Restate major edges** Although each line is strong as a mark in itself, the sketch is built up by a number of strokes for each edge. The important edges are often restated in order to make them read more strongly.

3 **Start with volumes and draw through** This technique is often used when drawing through volumes as if they were transparent, as we looked at in 'Outline the basic volumes' on page 18. It will help you achieve accuracy faster, as all the elements are tied together. The lines that represent the back sides of a volume are drawn lightly, and are often not noticeable in the final sketch.

4 **Guidelines** With this approach, the quickest way to sketch repetitive items is to draw a series of fine guidelines. For example, you would draw a top and bottom guideline for a row of windows to help them align perfectly when sketching at a rapid pace.

5 **Simple shading and hatching** The final step is to quickly add some hatching in the shaded areas to give the sketch some depth, and then add some darks to areas, such as windows.

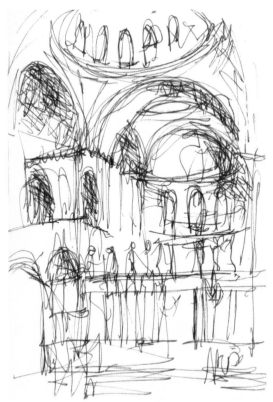

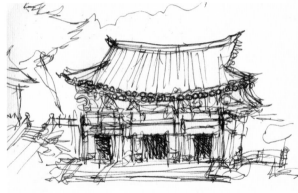

Above Liz Steel, *Temple, Seoul, Korea*, 2013.
During a short guided tour, I asked the guide if I could stop for three minutes to sketch, so I went crazy with rapid lines!

Left Liz Steel, *Inside San Marco, Venice, Italy*, 2010.
With this technique, you don't even need three minutes to stop for a sketch. Just keep sketching while you are walking!

Right Liz Steel, *Sydney Hospital, Sydney, Australia*, 2016.
This technique is not only for pen. Here, I used a pencil and lots of light, rapid strokes to align the various arches and windows.

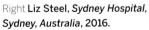

Rapid guidelines

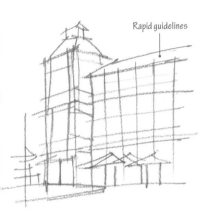

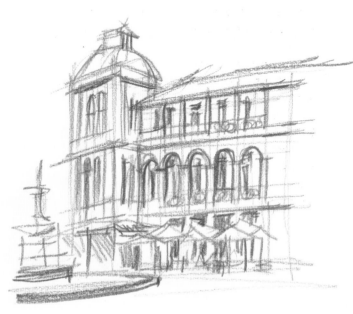

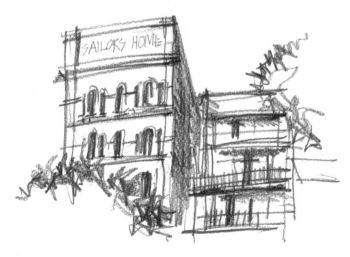

Left **Liz Steel,** *Sailors Home, The Rocks, Australia*, **2016.**
Using my 5 mm graphite lead meant that I couldn't even attempt to draw the architectural details, but using it on its side was great for quick shading.

Right **Asnee Tasna,**
Christ Church, Melaka, Malaysia, **2014.**
Using a brush pen, Asnee made many bold calligraphic marks that dance across the page.

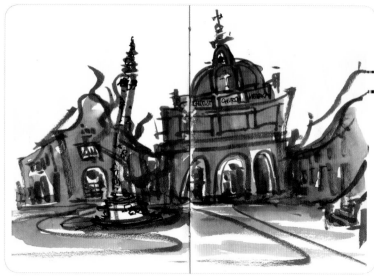

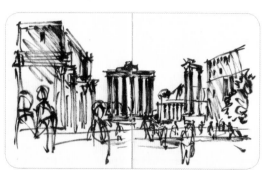

Left **Liz Steel,** *The Forum, Rome, Italy*, **2010.**
If I need to sketch something really quickly, I rely on my Pentel Pocket Brush Pen and just go for it. It's my 'fast tool'.

Try thick lines

Drawing with thick lines has many of the same advantages as working small in terms of simplification, but with a big difference. Working small is safe, as the pressure of drawing a wrong line is less apparent, but when you use a thick pen, every line is a huge statement. Once you come to terms with this, it can be a liberating experience!

Tips to get you started

1 **Be confident** The number one thing to embrace when using a thick pen is that every line must be drawn with confidence. Accept the fact that it might not end up on the page in the correct position, but it will be so strong that you have no option but to live with it and draw the next line on the basis of what you just drew!

2 **Draw from the shoulder** The more you can draw with a full arm movement, rather than tight wrist movements, the freer and stronger your lines will be. Think of each curved line as akin to a gesture, and each straight line as a bold statement.

3 **Work blind** Trust your eye-hand coordination and work blind (in other words, not looking at your page) as much as you can. The more confidence you place in this coordination, the easier it will be. Every line will not be perfect, but the overall sketch will be convincing if you believe in yourself.

4 **Try different tools** Experiment with a range of different pens. How does using a really thick marker compare with a 0.5 mm pen that is only a little thicker than you are used to? Use a thicker graphite pencil, or sketch with the side of a normal pencil. There are all manner of options to explore.

5 **Expressive lines** Try pens that produce a variety of different line thicknesses. Brush pens, dip pens and calligraphy pens with either stub or bent 'fude' nibs are especially fun to sketch with. These pens can be used in a controlled way, adjusting their angle to achieve a desired thickness, or they can be used with abandon and allowed to create expressive lines in response to your natural strokes.

Exploratory contour drawing

Working in a structured way – starting with the overall volumes and working inwards – is the most common approach to sketching architecture, but it's also fun to draw in a more exploratory way. Draw relying purely on your observational skills, working from one part to the next. The great thing about this approach is that you can stop at any time, or keep going if time permits.

Tips to get you started

1 **Work outwards** Pick a starting point, normally the most interesting part of a building, and start drawing one part after the next, working outwards. You are not trying to draw the whole building; rather, you are exploring the surface, edge by edge, and creating an experimental drawing. Using a continuous line is really helpful for this approach.

2 **Focus purely on relationships** How long is this edge in relation to the previous one? At what angle is it? Allow yourself to draw one edge after another, regardless of what part of the building they represent. Jump between windows, structural elements and texture, using a single line as much as possible.

3 **Switch between horizontal and vertical** You might like to alternate between exploring vertically and horizontally. If you follow an important edge, such as a ledge between two storeys, or a column, extend it out and then track back to include some of the details. This produces an open-ended pinwheel composition.

4 **Change thickness or colour** If you want to make it even more fun, have a few different tools handy, and change to a thick pen for the more important edges. Alternatively, use coloured pencils and change colours for the different elements.

5 **Go with distortion** Because this technique is about focusing on developing your eye-hand coordination and the relationships between one part of a building and the next, there is often a degree of distortion that naturally occurs. Go with it, and keep working.

Below **Liz Steel, *House and tree, Mosman, Australia*, 2016.**
I often do a quick three-minute continuous line sketch from my car when I am out and about. I add hatching later.

First continuous lines

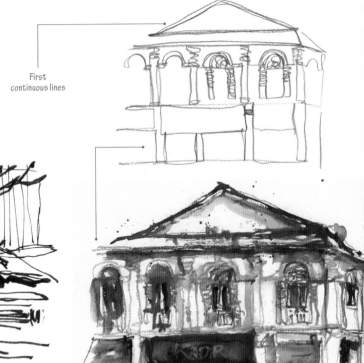

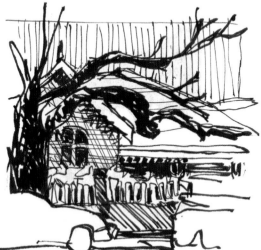

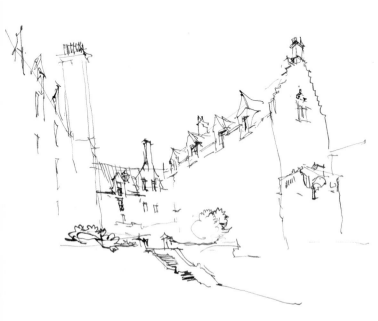

Above **Liz Steel, *Shophouse, Kampong Glam, Singapore*, 2015.**
Unsure how long I had, I started with a continuous line in watercolour pencil. I ended up having more time, so I just kept going.

Left **Marc Holmes, *Royal Victoria Hospital, Montreal, Quebec*, 2016.**
Marc was able to capture this building and its context by using a continuous line, starting with the outside and then drawing the internal details.

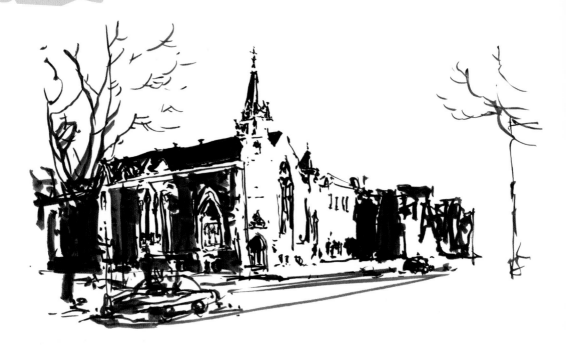

Above **Marc Holmes,** *Eglise Saint Jean, Montreal, Quebec,* 2016. By just drawing the shadow areas with a black brush pen, Marc has explained all the major elements of this complex building.

Below left **Liz Steel,** *Parròquia de Sant Pere Nolasc Mercedarios, Barcelona, Spain,* 2013. Similar to Marc's drawing, I adopted the same approach of only sketching the areas in shade, but used watercolour pencils and watercolour.

Below right **Liz Steel,** *Millers Point terrace house, Sydney, Australia,* 2016. In this quick study, I used markers to draw the shadow areas first. Notice the darker cast shadows on the sunny side and on the ground.

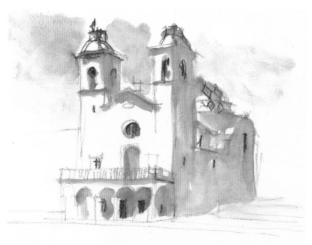

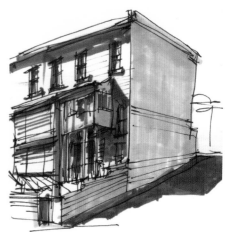

Map light and dark

When it comes to adding tone or colour to your sketch, the most valuable skill is the ability to see quickly which parts of the scene are receiving sunlight, and which are not receiving any. Thinking in terms of these two conditions as white and black and locking this in your memory – in other words, mapping these as abstract shapes – enables you to work quickly.

Tips to get you started

1 **Map the shadows** The first step is to visually think of all the areas that are not receiving any direct sunlight as big shapes of black. In itself, this mental black and white map is often all you need to record a scene. If you are pressed for time, use a pen with a thick tip or brush tip and only draw these areas.

2 **Form versus cast shadow** You can refine these areas of shadow by differentiating areas that are in the shaded side of the buildings (faces that are turned away from the direction of the sunlight), and those that have shadows cast onto them. In general, form shadow is often lighter, as it contains reflected light.

3 **Don't stress reflected light** Achieving beautiful, glowing colours in the shadow areas of your sketches is something that everyone strives for. But if you are working fast, the important thing is to make the overall shapes the right tone.

4 **Bold cast shadows** Cast shadows in relation to architecture are often strong with crisp edges. So don't be afraid to 'push' your shadows by making them darker than you think they are, as they will really make your sketch jump off the page. Remember, watercolour will dry lighter, so be bold and go dark!

5 **Added and subtracted shadows** Much of the three dimensionality of architecture sketches comes from the way that light reveals the changes in plane on the surface of a building. Look for the shadows cast by elements that are added to or subtracted from the main volumes.

Simple tonal values

Once you can separate areas of your scene into light and dark, you will want to refine them further and include the 'local' colour of objects as well so that your sketch contains a greater tonal range. This will create a tonal (or value) study. To do this, you have to convert all the lightness or darkness of each coloured shape into a shade of grey.

Tips to get you started

1 **Squint to see values** While mapping light and dark normally relies on an understanding of how light is hitting the volumes of a building, a tonal study is all about looking at the whole scene simply as shapes, so squinting is essential. Don't worry about whether something is a dark coloured object in sunlight or a light coloured object in shade; just look at its value as it appears to you.

2 **Add a mid tone** Look at the dark shapes and divide them into the darkest part (black) then a mid grey. Typically, this will be in areas of shadow, but depending on the colours in your scene, it might also include dark buildings or landscaping. You now have a tonal study with a value range of three: white, mid grey and black.

3 **Five value studies** Refine this further by adding two more values – one into the mid grey areas and a lighter grey into the areas of white. It's amazing how much information about light and colour these tonal studies contain. Look for interesting patterns in your value study, as this will make your sketch more appealing.

4 **Using markers** Markers are a great tool for these value sketches as they produce an even colour and can be layered. A simple soft pencil is good too, but you have to make sure your pressure is consistent and that you don't get distracted by breaking down the values into too many levels.

5 **Thumbnails as sketches** What we have described is a traditional value study that is used as a planning tool for a more careful painting. When sketching quickly, make this thumbnail a little bigger and just use it as 'the sketch', or try doing this as a mental exercise before you start. The more you think about values, the more it will inform your work.

A

B

C

 — Five-step value chart

Above **Liz Steel,** *Manly Flats, Sydney, Australia,* **2013.**
I started with mid grey shaded areas (A), then darker shadows (B) and finally a light grey for the sky and window panel (C).

Right **Liz Steel,** *Casa das Rosa, Sao Paulo, Brazil,* **2014.**
Here I used the same principle, except with an ochre watercolour pencil for the light tones and a grey brush pen for the darker ones.

Bottom **Virginia Hein,** *Olvera Street, Los Angeles, California,* **2015.**
In these three thumbnails, Virginia explored a number of dramatic compositions with just three tones – black, mid grey and white.

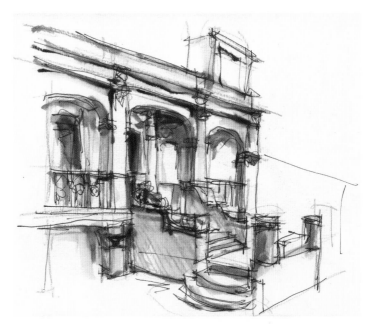

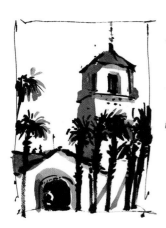

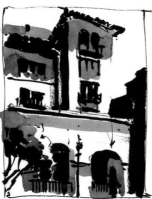

89

Right **Liz Steel,** *Manly Wharf, Sydney, Australia,* 2016.
Using a dark watercolour pencil with a wedge edge to the lead, I was able to draw the outlines and shade big dark areas rapidly.

Below **Liz Steel,** *James Boag Brewery, Launceston, Australia,* 2015.
There is no reason why you can't use these techniques with a variety of coloured water-soluble pencils and a little water, as I did here.

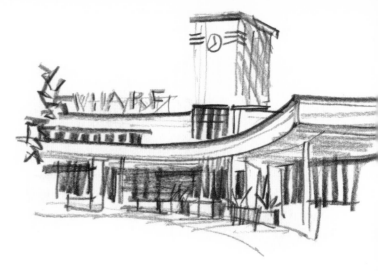

Below and below left **Matthew Brehm,** *Lisbon street scenes, Lisbon, Portugal,* 2011.
In these two thumbnails, Matthew has captured a lot of details with just a few strokes and skilfully adjusted stroke direction to create depth.

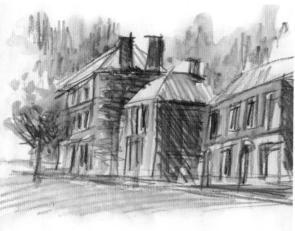

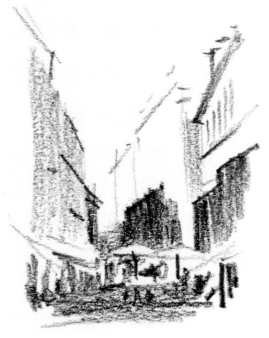

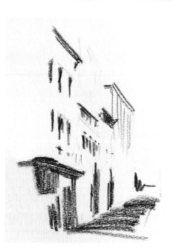

Shade quickly

The easiest way to refine areas of shadow is to add some variation with pencil shading. Because you are able to get a huge variety of strokes by adjusting the pressure of a pencil and by using its lead on its side, you have lots of options with this one tool. The same principle applies with coloured pencils.

Tips to get you started

1 **Get to know your tool** Because of the huge variation possible with pencils, make sure you know the range of marks you can achieve with the one you have – how light, how dark, how thick and how thin. The better you know your pencil the more you will be able to get the marks right the first time. See 'Quick pencil' on page 108 for more tips.

2 **Rapid stroke movements** The key to shading quickly is to establish a good rhythm of rapid strokes, all applied with the same energy and pressure. It is also good to practise controlling the start and stop of your strokes. Can you shade quickly while still staying roughly within the lines?

3 **Start with the darks** While a traditional approach to shading with pencil is to start light and build up the tones gradually, when you are sketching fast you have to just 'go for it' with the darks. It is therefore much quicker to apply shading to the dark areas early on, and then decide how much of the lighter tones you need to apply.

4 **Vary your pressure** Whereas in 'Map light and dark' (page 86) we were thinking of the shadows as large dark shapes, when you are using a pencil, you have the ability to adjust the tones in these areas by simply varying your pressure. Make sure that you use the greatest pressure for the darks in the focal point of your sketch.

5 **Change direction for different elements** By simply adjusting the direction of your strokes, you can add a lot of depth to your quick shading. This direction can describe horizontal or vertical surfaces and also indicate texture.

Hatch and cross-hatch with speed

While you can hatch with lots of different media, pen is the most popular. Cross-hatched pen sketches generally take a long time and are associated with a meditative state that suits getting lost in the details. But you can do it quickly if you have a few strategies for sketching the important features first. Once these are completed, you can continue to cross-hatch to your heart's content if time permits!

Tips to get you started

1 **Rhythm** Just as we saw with 'Shade quickly' (page 90), the secret to cross-hatching is to establish a good rhythm with your strokes – a rhythm of your hand moving across the page. Experiment to find which direction suits you best. It is normally easier to pull your pen across the page rather than push it, so this means that a left-hander is more likely to work from right to left.

2 **Volumes and shaded areas** The key to not getting lost in the details early on is to stick to the main volumes and then rapidly add diagonal hatching to any areas of form or cast shadow. If you run out of time, at least you have all the important parts on your page, so it's mission accomplished!

3 **Add texture** However, if you still have a little time, the next thing to decide is how much texture you're going to add. It is really easy to overdo this step, so squint to see what the most important texture patterns are, and then add

those first. Apply hatching in the direction of the texture, for example the horizontal bands of brick coursing.

4 **Add cross-hatching** You will then want to quickly review what you already have on the page and start adding strokes in a different direction to build up tone. Rather than the traditional cross-hatch of two layers at 45 degrees, experiment with vertical and horizontal lines in conjunction with angled lines. Don't forget to add some spots of pure black as well.

5 **Local colour treatment** The final thing is to decide how you are going to represent the local colour of the different elements. Will you use hatching or colour, or not record it at all? Often you will find that unless your scene contains an important contrast between light coloured elements and darker ones, you might not need to indicate it at all. If you do add colour, it only needs to be simple.

Right Liz Steel, *Arthur's Circus, Hobart, Australia*, 2015.
On a grey day there weren't many shadows to record, so I focused on the textures of the fences, roofs and trees.

Below Liz Steel, *Epping School of Arts, Sydney, Australia*, 2015.
I started this while waiting for a friend and got all the drawing done in a few minutes. I then built up the tones and added colour at home.

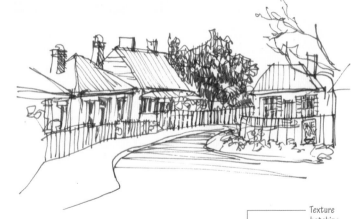

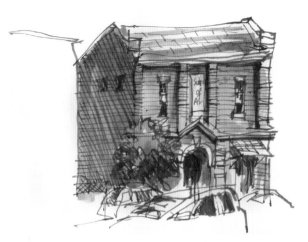

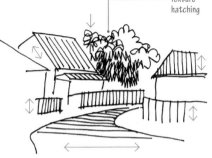

Texture hatching

Below Richard Alomar, *Boston Commons State House, Boston, Massachusetts, USA*, 2014.
In this loose sketch Richard has built up the tones to create dark shadow areas and a strong sense of depth.

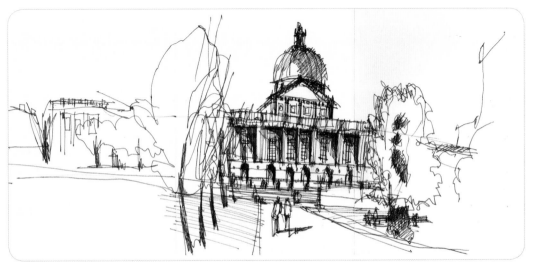

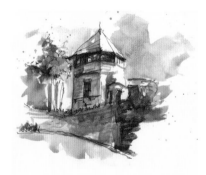

Above **Liz Steel**, *Mosman sandstone house, Sydney, Australia*, 2015.
I normally rely heavily on the white of the page and warm shadow areas to express Sydney's bright midday sun.

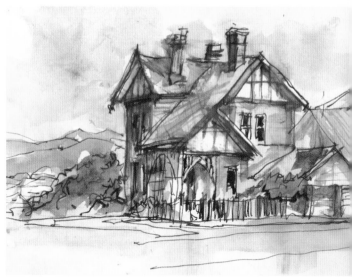

Above **Liz Steel**, *Corner House, Launceston, Australia*, 2015,
Tasmania's light is softer than Sydney's, particularly at dusk, so I applied a light golden wash over the top to express this.

Left **Virginia Hein**, *Downhill view, Los Angeles, California, USA*, 2012.
Using a burnt sienna pencil, Virginia sketched this from the passenger seat and then applied gouache over the top later, achieving a perfect afternoon glow.

Catch the light

Getting strong and compelling lights and darks in your sketches is really important, but after a while you will want more. You will want to capture the mood of the lighting – not just value, but the colours as well. Good contrast through use of values is still important, but the correct temperature of the colour (whether it is warm or cool) is essential to capturing the light.

Tips to get you started

1 **Angle of the sun** The quality of light is dependent on the position of the sun in the sky. When it's higher, the light is brighter and cooler, and when it's lower it produces a softer, warmer light. This reflects not only the time of day, but also the time of year (the sun is higher in summer) and where you are in the world (the further from the equator, the softer the light).

2 **Midday sunlight** Noon summer sunlight produces the brightest light with the strongest contrast. The shadow areas will be dark and the sunlit surfaces very bright, to the point that you can express them as white. When you are sketching with transparent media, this means letting the white of the page do the work by leaving these areas unpainted. Fewer areas to paint equals faster sketching!

3 **Warm light** At dawn or dusk, everything has a golden glow and this is traditionally achieved in watercolour by putting down a warm under wash. However, when you are sketching quickly, you won't have time to wait for this to dry. Therefore, consider adding a light wash over the top when you are back home. Alternatively, start with a warm pencil (raw sienna) as the first layer and add paint over the top.

4 **Reflected colour** When using watercolour, consider dropping a warm colour like raw sienna into a wet wash to achieve a glowing shadow; this will really express the quality of the reflected light.

5 **Cloudy days** On a cloudy day there is less contrast between light and dark. In fact it is often hard to distinguish what is what because the light is flat. Try to work out which sides of your subject would be light and which would be dark if it were sunny, and then make this distinction in your sketch. However, make sure the contrast isn't too great.

Play with contrast

Following on from the idea of catching the light (see page 94), you will next want to think about manipulating the contrast and values of the main shapes so that the eye is pulled to the most important part of the sketch. This is especially important when your subject matter is a dark coloured building, as it is easy to overdo the initial local colour and produce a dull sketch.

Tips to get you started

1 **Bleach local colour** As we saw earlier, it's good to think about the areas of the building that are receiving direct sunlight as being lighter in tone than you think they are. This is particularly the case for dark buildings. 'Bleaching' these areas – painting them in a lighter tone than you think they are – will prevent a dark building from looking heavy.

2 **Start with shadows** A great way to make sure that you don't lose your highlights is to start painting the shadow areas first. Sometimes painting just those will give you all the information you need about a building, and you won't need to add anything more. The strong contrast between the white paper and the dark painted shapes will make your sketch dramatic.

3 **Add sky last** Traditional watercolour painting often starts with putting down a wash for the sky, but when sketching spontaneously on location, it might be better to leave the sky until last. That way you can decide whether the sketch needs the sky to strengthen the focus, and you will be able to adjust its values for the areas of blue or clouds to suit the composition.

4 **Contrast at the focus** As the eye is drawn to the area of greatest contrast in a sketch, think about putting the darkest dark next to the white of the page or a light toned area at the focal point. To strengthen this further, lessen the contrast between the lights and darks in peripheral areas of your sketch.

5 **Push the colours** Many buildings are built from materials with neutral or earth colours, and often have a lot of mid tone grey. So to create a more appealing and eye-catching sketch, allow yourself the freedom to play with the value and intensity of the colours. Make colours stronger, brighter, darker or lighter. It's your sketch – do what you want!

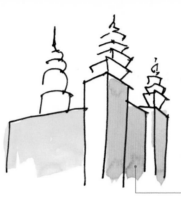

Left and below **Liz Steel**, *Luna Park, Sydney, Australia*, 2016. This building didn't really need its colours 'pushed', but I still increased the yellow's intensity on the shady side to capture the afternoon light.

Pushed colour creating contrast

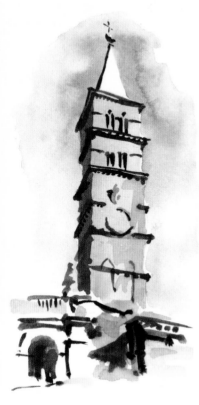

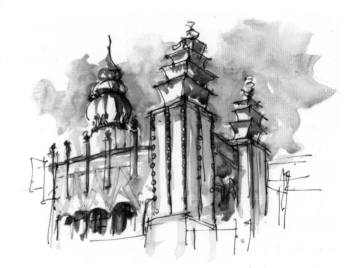

Above **Matthew Brehm**, *Santa Maria Maggiore, Rome, Italy*, 2012. Although this is a mid tone red brick tower, Matthew has 'bleached' the colour on the sunlit side to a much lighter shade. However, it looks right!

Right **Liz Steel**, *Epping Uniting Church, Sydney, Australia*, 2013. Because of the bright side lighting at the time, I kept the lit faces of this brick church as the white of the page.

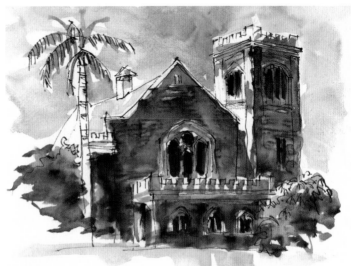

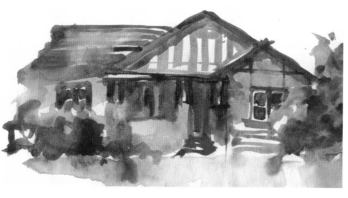

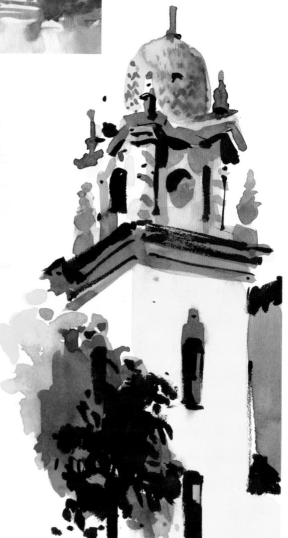

Left **Liz Steel**, *Blue house, Sydney, Australia*, 2014.
Working with much wetter washes, I allowed the happy accidents to happen, but made sure they were dry before adding the maroon details.

Above **Liz Steel**, *Chatswood High School, Sydney, Australia*, 2012.
After a few very basic set-up lines in yellow, I left some white strips between the washes so the colours didn't run together.

Right **Virginia Hein**, *Olvera Street, Los Angeles, California, USA*, 2015.
Virginia used lots of hard edges, making the tower look solid, but went with wet-in-wet washes for the curved dome.

Just use paint

You might think drawing is much quicker than painting because all you need to do is grab a pen and start! But once you get over the initial mental hurdle of getting your paints out, you'll discover that paint can be much faster, as the big shapes go down very quickly. The simple act of getting your paint out at the beginning could dramatically increase your speed sketching skills!

Tips to get you started

1 **Focus on big shapes** You know all about this by now, but the secret of a quick, paint-only sketch is to focus on the big shapes. Look for these but vary the way you paint them. Vary your strokes, leave areas of the paper, and change the pigment-to-water ratio slightly as you work.

2 **Control water** When you're working quickly with watercolour washes, you have to be very conscious of how much water you are using. If your washes are too wet they will merge together, losing all definition between the shapes; if you don't have enough water, your paint will look too patchy. Strive for variety between edges that are hard and defined and some that are soft and merged.

3 **Happy accidents** The great thing about watercolour is that it is hard to control. Yes – this is a positive and not a negative aspect! So don't stress out about washes that mix together or back runs; allow these to add to the spontaneity of the sketch. Embrace the happy accidents!

4 **Finer brush details** If you have the time and have been using washes that dry quickly, add some more details to define the important edges with a thicker watercolour mix and a finer brush. If you don't have time, do this later, as it is important that the first washes are totally dry before you add these painted lines over the top.

5 **Lines not needed** It has a very different look from the strong black outlines of an ink and wash sketch, but you will be surprised at how robust and defined a paint-only sketch can look. The secret is to have strong washes with hard edges at the important part of your sketch – at the focus.

Sketch over loose shapes

If you want to combine paint and line in a lively way, try painting first and drawing second. Initially it's a lot harder to get accuracy with the paint, but it will make you much more conscious of colour and value. Drawing the lines over the top will add precision and pull the shapes together. There are a lot of fun surprises in store for you when using this technique!

Tips to get you started

1 **Big, loose washes** Look at the overall silhouette of the building and start with a big watercolour shape for this. Then add some variety with a darker version of the same colour, or a contrasting one. No need to be too careful.

2 **Correct with pen** When you first try this technique, your shapes are probably going to be a lot less accurate than your lines, but this inaccuracy creates an exciting vibration within the sketch. You will realize that the precision of the shapes doesn't matter so much, giving you greater freedom when you paint.

3 **Just paint the shadows** When you become more confident sketching with watercolour shapes, you might want to just paint the shadow sides of a building and then only rely on line to define the areas in direct sunlight. Work quickly with wet washes and allow the different shapes to merge.

4 **Ink bleeding** You might find that the ink lines bleed a little when you draw over the top of watercolour washes, but that's OK! This technique is not comfortable for people who like precise lines, but just go with it. You might want to live even more dangerously and draw into wet washes with a pen! The ink will bleed and even float over the surface of the water, creating totally uncontrolled, expressive lines.

5 **Splash** Go crazy and have fun! Splash, drop in unexpected colour or use a really big brush for those first washes. The looser and freer, the better. Architecture sketching doesn't have to be serious all the time!

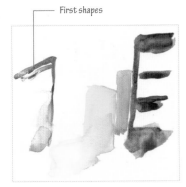

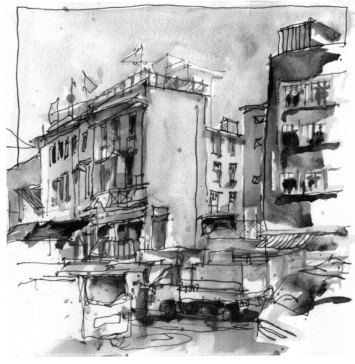

Above and right **Liz Steel,**
Coloured buildings, Chinatown,
Singapore, **2015.**
Although quite elaborate, this sketch
started with strong coloured shapes
for the different buildings.

Below **Liz Steel,** *Cottage, Kingston,*
Norfolk Island, **2015.**
I was working with very wet washes,
so drawing over the top of them
made my ink lines bleed in places,
creating a very expressive sketch.

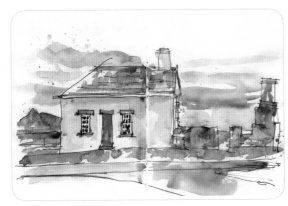

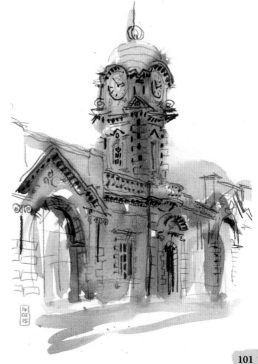

Right **Lynne Chapman,**
Nottingham Railway Station,
Nottingham, UK, **2015.**
Lynne's initial coloured shape is very
loose, with contrasting dropped-in
colour and lots of soft edges, but her
lines pull it all together.

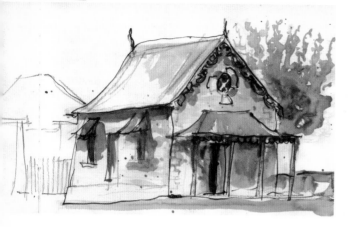

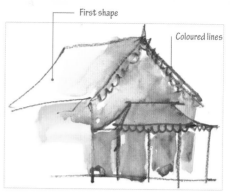

First shape

Coloured lines

Left and above Liz Steel, *Old Ryde Courthouse, Sydney, Australia*, 2013.
I started with a sandstone coloured wash and then used coloured lines to describe the building, adding a little more paint to the roof and the adjacent tree.

Below Liz Steel, *Street corner, Paraty, Brazil*, 2014.
Switching between drawing in watercolour pencil, painted lines and a few patches of colour was a lot of fun in this quick sketch.

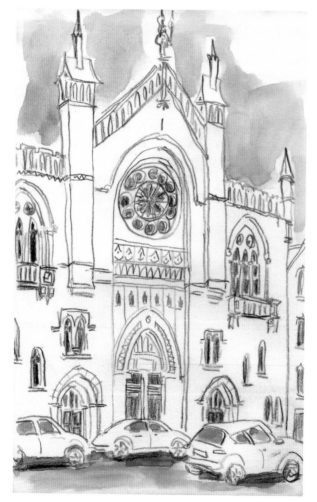

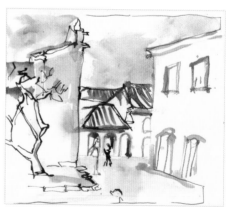

Left Lynne Chapman, *Leeds Church, Leeds, UK*, 2014.
With a crazy multicoloured lead, Lynne was able to create a fun sketch in no time, and a few selected coloured shapes gave it depth.

Coloured lines and minimal paint

As waiting for paint to dry and controlling adjacent washes are the aspects of watercolour painting that slow you down the most, you might want to limit the use of paint to more isolated areas and use coloured lines to do a lot of the work. These lines can be made with pencils, pens or paint and can interact with the coloured shapes in fun ways.

Tips to get you started

1 **One patch of colour** A good way to use this style of sketching is to put down one patch of colour at the beginning. Then, pick up a coloured pencil and start drawing over the top or adjacent to it. You will be surprised by how much that initial area of colour affects the whole way in which you approach the sketch.

2 **Different colours for different elements** Get a collection of pencils (watercolour pencils are the best) and draw element after element, switching between colours as you do so. Rather than starting with paint, you might prefer to just sketch in line and add patches of colour at the end. Either way is good!

3 **Mix it up** However, the best way to use this technique is to switch between line and colour frequently during the sketch. As soon as you feel settled with one medium, switch back to the other. This constant mixing it up creates a sense of play and also helps with separating wet washes, meaning that you can work faster.

4 **Make it up** You don't need to have a coloured pencil that matches the exact colour of the building element you are drawing. Choose the one that is closest or simply do something different. There are no rules; just have fun playing with colour.

5 **Go with any distortion** With all the focus in this technique on experimentation with line and colour, don't waste any of your creative energy thinking about accuracy. Just go with any distortion. You might be surprised at how good the results are.

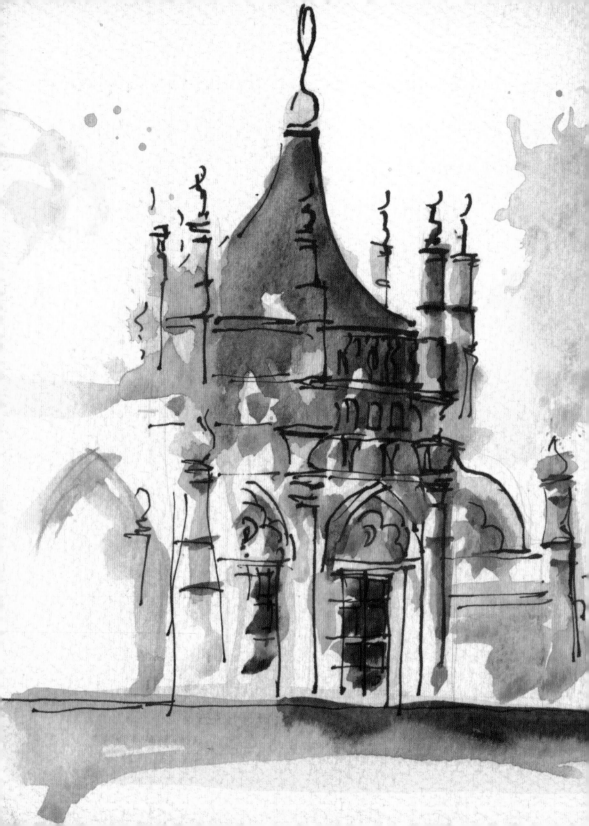

Speedy supplies

It is tempting to think that there is a perfect sketching kit out there that will enable you to work faster, but the simple fact is that it doesn't exist! Not only that, the biggest issue is not what tools you have, but how well you know them and can use them confidently in the blink of an eye. Someone else's magic tool will not instantly produce a masterpiece for you. The ability to use a particular tool for fast sketching is completely dependent on your own experience of what it can do – how it will behave when you use it quickly or slowly, on dry paper, over wet paint or when water or watercolour wash is applied over it. This chapter will go through a range of different media, emphasizing quick techniques for using them. Choose a few and test them out for yourself.

Left **Liz Steel,** *Yellow Mosque, Singapore,* 2014.
This sketch makes the most of quick paint techniques, working wet-in-wet, taking risks and letting washes merge.

Quick ink

Many of the sketches in this book were done with permanent ink for the lines, and watercolour for the colour. The ink can be in a permanent fineliner pen or special pigmented ink in a fountain pen. Either is fine, but a fountain pen will give you more expressive lines due to its liquid ink and options for different types of nibs. And there are lots of options with coloured ink, too!

Tips to get you started

1 **Be bold** Whatever ink pen you use, the secret for fast, confident sketches is to make sure that you are bold and decisive with your lines. If you draw a wrong line, take a deep breath and then either correct it with a single line, or just go with it and keep sketching. Never be tentative or draw lots of lines in a panic to correct a mistake.

2 **Water-soluble ink** While there is a great demand for good permanent ink tools among sketchers, water-soluble ink lines have the wonderful advantage of being able to easily transform a sketch from line to tone in seconds. By simply applying a little water to one side of the line, you can create a wash while still preserving the crispness of the edge on the other side.

3 **Ink washes** Ink doesn't have to be in a pen. You can use it to create quick, dramatic washes by applying it with a brush and adding water to lighten the tone. Just take care with your bottle of ink when out on location!

4 **Use a different colour** One of the great things about using ink is the huge range of colours that are available. Don't get stuck thinking you have to use black; not only will a different colour change the mood of your sketch, it might change your mood too. There is something very stark about black ink, so changing to a softer colour might allow you more freedom with your lines.

5 **Change colours** As already discussed (see page 102), you can use a number of different coloured lines to create a lively sketch. But you can also load up a few different water brushes with coloured ink and apply line and colour shapes very quickly. This is a super fast way of sketching!

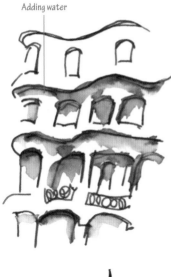

Adding water

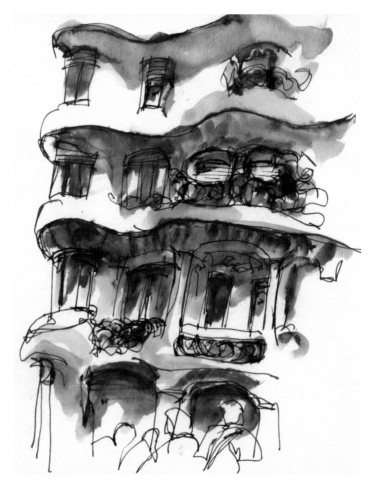

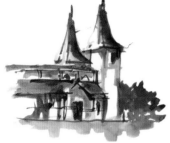

Above **Liz Steel**, *St. John's, Parramatta, Australia*, 2014.
I used two water brushes filled with yellow and green ink and a black fountain pen, and then added a few watercolour washes over the top.

Above right **Liz Steel**, *Casa Mila, Barcelona, Spain*, 2013.
Using water-soluble ink enabled me to quickly create soft lines and washes that described the concrete staining of this iconic building.

Right **Peter Andrews**, *Filbert Street, San Francisco, California, USA*, 2013.
Peter brought this loose ink line drawing to life with a few quick washes from a water-soluble ink pen, adding depth and texture.

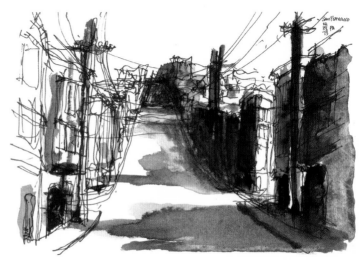

Right **Liz Steel,** *Sydney University, Sydney, Australia,* 2013.
I love using water-soluble graphite pencil, as I can vary pressure while drawing and also lose parts when I add paint.

Below right **Matthew Brehm,** *Life Science Building, Moscow, Idaho, USA,* 2012.
Matthew demonstrates the versatility of a single pencil with a huge variety of marks, shading and tone in this small sketch.

Below **Suhita Shirodkar,** *Victorian home, San Jose, California, USA,* 2016.
Suhita has made the most of hard, crisp edges and smudgy marks in this quick five-minute charcoal sketch.

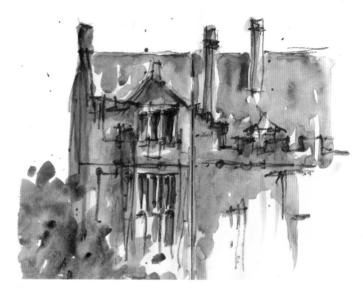

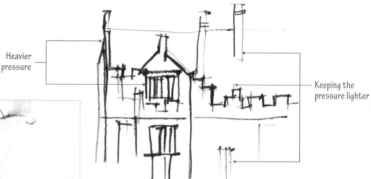

Heavier pressure

Keeping the pressure lighter

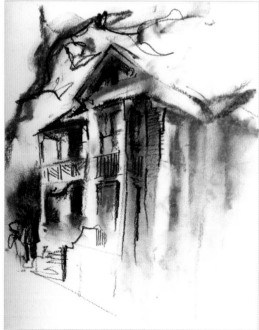

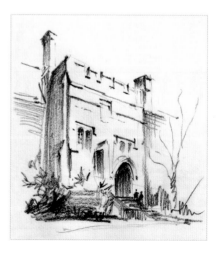

Quick pencil

As we have seen previously in 'Shade quickly' (page 90), the humble pencil is a mighty tool, being able to create a huge variety of marks. Explore the marks you can make with it and which softness suits you best. The softer the pencil, the greater the range of marks, but the more you will have to sharpen it for crisp details. There are also water-soluble graphite pencils to explore.

Tips to get you started

1 **Change pressure** The secret of getting the most out of your pencils is to have a good feel for how much pressure to apply to get the value of line that you are seeking. Having experience of how much pressure to apply to achieve exactly the mark you want is an essential skill when sketching quickly.

2 **Varying hardness** In order to get the most out of pencils, you might want to carry more than one – a harder pencil for crisp edges and a softer one for shading.

3 **Wedge lead** Rather than sharpening your lead to a point, use a knife to create a long lead with a wedge point; this will allow you to achieve greater mark variation. And if you need to sharpen your lead while out sketching, just run it down the pavement and it will create a nice, sharp edge.

4 **No rubber** Many people find that when they use a pencil they start fussing and have an uncontrollable desire to erase their lines until they are correct. When you are sketching quickly there is no time for rubbing out, so leave this tool at home!

5 **Smudge** Using a soft pencil or a charcoal pencil gives you the option of creating tone by smudging, either using a pencil stump or your fingers. The soft and variable nature of charcoal means that it is ideal for loose sketches of architecture, and the smudging means that you can correct any line at any time.

Quick coloured pencil

Coloured pencils are normally associated with precise realistic renderings that are built up slowly, layer upon layer. But they can also be used quickly in sketching, either for loose rapid colouring within ink outlines, or on their own. Either way, being a dry medium, they are very convenient when out sketching, as there is no drying time.

Tips to get you started

1 **Quick colouring** Don't think about the traditional careful building up of layers, but rather think rapid strokes instead. Just as we saw in 'Shade quickly' (page 90), it's all about developing consistent hand movements. If you are colouring over an ink drawing, there is no need to worry too much about staying within the lines as they will hold everything together. So take risks and colour rapidly!

2 **Coloured lines and shapes** However, to work even faster, leave your pen in your bag and go straight to coloured pencils. Use different coloured outlines for all the major components in your scene and then add some shading and texture to the important parts of your sketch.

3 **Layering colour** Because of the translucent nature of coloured pencils, they can be mixed to create an endless range of colours. Their translucency means you can layer lighter colours over the top of darker ones, lightening or shifting their hue. Because getting your darks down early is a powerful fast-sketching technique, coloured pencils are perfect for this, as they give you an option of playing with your dark areas.

4 **Stroke direction** Make the most of the linear nature of coloured pencils and apply them in the direction of the texture you are recording. You can also mix up your strokes in the one sketch by hatching and cross-hatching in different directions, stippling and scribbling.

5 **Limited colours** Most brands offer an enormous range of colours, but it's better to start with a limited selection that you really get to know. A good starting point is a primary triad (yellow, red and blue), plus an earth yellow, an earth red, a dark muted blue (such as indigo), a mid grey and a white. After a little while you will know which important colours you are missing.

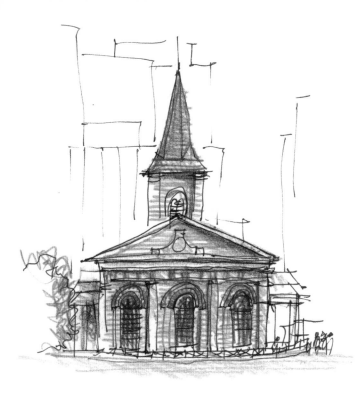

Left **Liz Steel**, *St. James, Sydney, Australia*, 2016.
Using a limited palette, I quickly coloured an ink drawing, changing stroke direction in a number of areas to provide texture.

Below **Peter Rush**, *From the Astor Hotel, Milwaukee, Wisconsin, USA*, 2015.
Who says coloured pencils are slow? Peter uses them really quickly, combined with very loose ink lines.

Below left **Carol Hsiung**, *High Line, 21st Street, New York, USA*, 2014.
Making the most of coloured pencils for lines and shapes, Carol sketched this complex scene in a few minutes.

Limited palette: mauve, ultramarine, brown ochre, burnt sienna, dark indigo

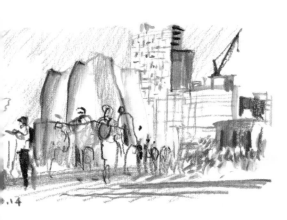

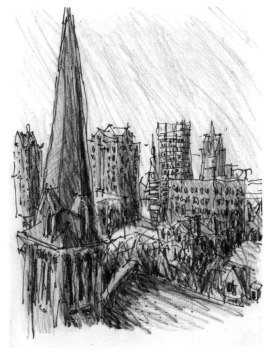

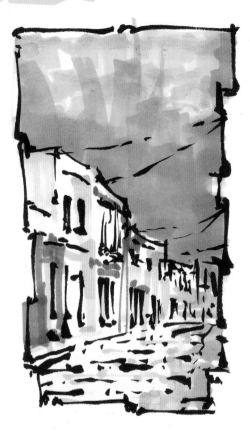

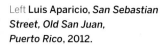

Left **Luis Aparicio, *San Sebastian Street, Old San Juan, Puerto Rico*, 2012.**
In this small sketch, Luis shows that markers can be used in a spontaneous way with lots of short strokes.

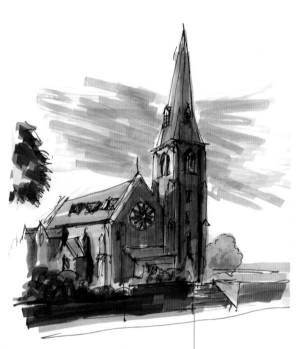

Below **Liz Steel, *Museum of Sydney, Sydney, Australia*, 2015.**
I combined a Payne's grey watercolour marker with a matching fog grey permanent fountain pen ink for this quick monotone sketch.

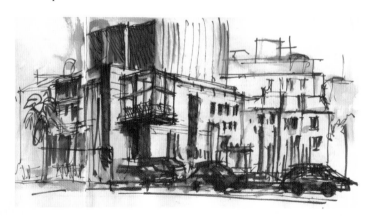

Above and right **Liz Steel, *St. Leonards Church, Sydney, Australia*, 2012.**
Using markers with very rapid strokes, I was able to apply the colour in only a few minutes and achieve glowing shadows.

Quick markers

Using markers has the advantage of being able to apply layers of transparent colour without any drying time. They can produce consistent areas of colour without visible stroke marks, and are more controllable than watercolour. However, alcohol-based markers will bleed through paper very easily. There is a range of different types of markers to explore, including watercolour markers.

Tips to get you started

1 **Limited colours** Just like coloured pencils, it is tempting to collect every colour in a range just in case you need them. But it is much better to use a limited selection of colours that work well together and not over-worry about colour matching your subject matter.

2 **Layer colours** One of the great characteristics of markers is that you can layer colours and achieve glowing results without the risk of creating murky colours, as with watercolour. Layering the one colour will build up a darker tone, meaning that you don't need to carry as many markers with you. Explore adding colours over a light raw sienna base for warm shadows.

Layering

3 **Consistent washes** One of the advantages of alcohol-based markers is that if you apply them with a continuous movement, you can get seamless washes of colour. This is normally associated with more precise work, but as you have to apply quickly while the marker ink is still wet, it's a very fast technique!

4 **Short strokes for texture** Using old markers or applying new ones in short, rapid strokes will create interesting textures as they overlap. This will give your sketch a lively character and prevent your marker work from looking too clinical. And you don't have to stay within the lines either!

5 **Add water** Watercolour markers, which are a relatively new product, work really well for applying colour quickly and then adjusting or softening with a bit of water. You might like to combine them with more permanent lines for interesting effects. However, remember that they are still markers and not really a true substitute for watercolour pigment applied with a brush.

Quick paint

There are quite a few factors in being able to successfully apply watercolour paint quickly. To begin with, you need to know your colours well and have a feeling for the water to pigment ratio necessary to get a wash of the colour you want. The more you know about your paints, the more you can use them with confidence and speed!

Tips to get you started

1 **Quick mixes** A lot of precious time can be wasted trying to mix up a colour that matches an element in your scene. Get to know your paint at home first and work out the best way to mix standard colours before you go out sketching. A limited palette of three colours is great for unity, but you need to do your homework so you can mix them quickly.

2 **Juicy washes** Pick up as much paint as you can with your brush and apply it in one go, varying your brush strokes. Then leave it alone and go onto another part. Whatever you do, don't start fiddling! A good thing about sketching quickly is that you'll have no chance to fiddle or overwork your washes, so your sketch will be fresher.

3 **Wet-in-wet** Have fun dropping colour into wet washes and let the pigment create texture and interesting effects for you. This is particularly useful if you have large areas of one colour. If you let it, watercolour will do a lot of the work for you!

4 **Take risks** If you are painting over ink lines, then you can afford to take risks, putting down washes in close proximity to each other. If the washes mingle, don't panic! Either pick up a bit of the paint back runs immediately with a clean damp brush, or let the watercolour do its own thing. Your lines will hold the sketch together.

5 **Texture** Apply your brush strokes in the direction of the texture of the building. If you rely on the paint to tell the texture story, then you have saved a lot of drawing time. Get your washes to do more work – colour as well as texture at the same time.

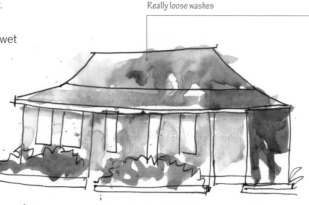

Really loose washes

Below **Liz Steel, *The Fox Hunter's Return, Campbell Town, Australia*, 2015.**
Unlike the Norfolk Island picture at the bottom of the page, here I used my brush strokes to express the building texture, and the mingling washes only added to the sketch.

Right **Asnee Tasna, *Tan Jetty, Penang, Malaysia*, 2015.**
This scene was simplified by Asnee into big shapes applied with expressive brush strokes.

Bottom **Liz Steel, *Homestead, New Farm, Norfolk Island*, 2015.**
As the lines were doing the work, I could allow my washes to be loose. However, they were still applied with deliberate strokes.

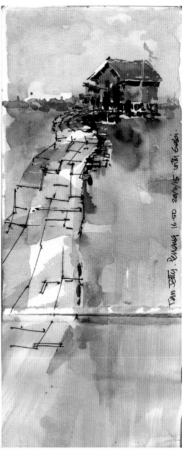

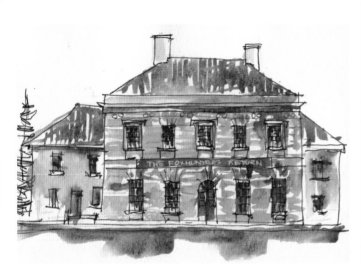

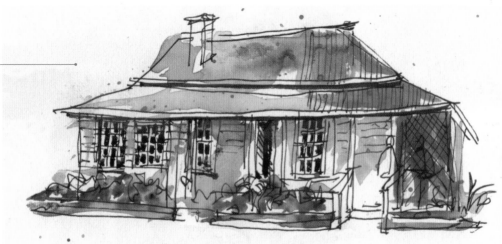

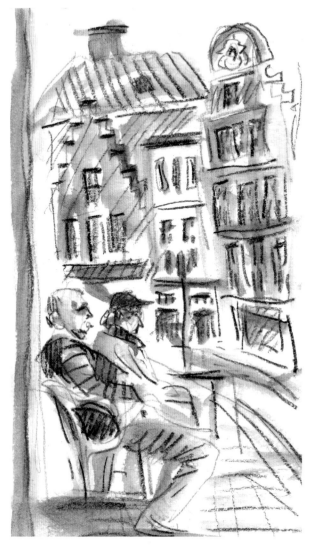

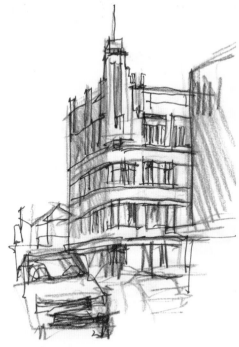

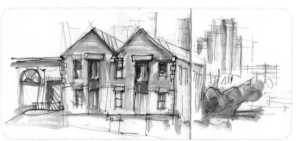

Above **Liz Steel**, *Holyman's Building, Launceston, Australia*, 2015.
I did intend to add water to this sketch, but the quick strokes of colour in their dry state looked good enough, so I left it as it was.

Above left **Lynne Chapman**, *Ghent street, Ghent, Belgium*, 2013.
Lynne used a limited palette, and once her drawing was completed only added a little water so the pencil strokes would still be very dominant.

Left **Liz Steel**, *Millers Point view, Sydney, Australia*, 2014.
I used watercolour pencils for the outlines and texture before adding some watercolour over the top and a few ink lines to finish.

Quick watercolour pencils

Watercolour pencils have numerous characteristics that make them incredibly fast sketching tools. They can be adjusted with pressure, provide colour and texture when used dry and can be mixed with the application of water. Having a few in your kit can come in handy when you are in interior spaces like museums or churches, where watercolour isn't allowed.

Tips to get you started

1 **Monotone sketching** Watercolour pencils are great for monotone sketching, as you can get a variety of tones with one tool and then adjust this further by adding water. This not only changes the texture, but sometimes the hue as well.

2 **Wet and dry** It is important that you get to know your watercolour pencils before taking them out sketching. Some colours have a big shift in hue or intensity when water is added, which can be an unpleasant surprise. If you are mixing colours, you need to get a feel for what pressure to apply to each colour to get the result you want.

3 **Change colour** You don't need a huge selection of colours, as, like coloured pencils, they can be layered so well. For example, if you are trying to limit your kit, there is no need for a green when you can easily mix one with a yellow and blue. These mixed colours will have a lovely texture that is hard to achieve with other media.

4 **Add a little water** Watercolour pencils don't need much water to activate them. In fact it is easy to wash away the texture and colour if you add too much water, so be careful! Retaining some of the original texture with the wash creates the most expressive use of watercolour pencils. And of course, you don't need to add water at all; you can just use them the same way as coloured pencils.

5 **Combine with paint** As some watercolour pencils can easily lose intensity, you might want to explore applying watercolour over your pencil work. This has the benefit of maintaining the desired colour intensity and/or adjusting the hue by adding a different coloured wash over the top. For example, you could add grey wash over a bright pencil work to neutralize it.

Sketch first, colour later

When your time is limited (for example, if you are waiting for someone), you have to make a decision early on about whether you are going to apply colour or not. Often the extra time it would take to get your colour out (particularly if it's paint) can be better used by just drawing as much as you can of the scene. You can then add colour later on.

Tips to get you started

1 **Five-minute steps** If you are not sure about your time frame, approach your sketch in five-minute increments and start thinking about the next step ahead of time. The first step is to get the main parts recorded; then if you get another five minutes add some more details, and if you still have time you can get your paint out. If not, you will be ready to add colour later.

2 **Record information** Make sure you record all the lines you need to define the different colour shapes. This will include edges where the colour changes (such as different building materials) and the outline of the shadow shapes. As we have seen previously ('Hatch and cross-hatch with speed', page 92), consider adding some hatching to indicate shadow areas, as it will immediately add three-dimensionality to your sketch.

3 **Photo or colour notes** Take a reference photo by all means, but it is more useful to spend a few moments thinking about the colour and/or jotting down a few notes. This will register it in your creative memory more firmly than simply taking a photo, and will mean that when you add colour later on, it will be more personal. Don't paint from the photo; only use it as a prompt for your memory.

4 **Colour quickly** It is important that if you add colour later, you do it in a similar style to the way you drew your lines. If you were working rapidly, get warmed up by drawing some quick strokes first, before applying paint. That way your paint strokes will have the same energy as your lines, which is essential for the unity of the sketch.

5 **No need for colour** The ironic thing about this approach is that once you have walked away from the scene, you will often find that you like your sketch just the way it is. Maybe there is enough information included in the line work to indicate colour, or maybe you just like the simplicity of a line drawing. Your intention and the end result do not need to be the same thing.

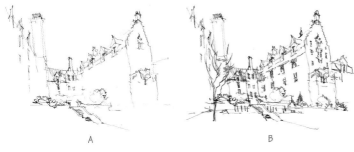

A B

Left and below **Marc Holmes,**
Royal Victoria Hospital, Montreal,
Quebec, **2016.**
Marc completed this sketch in five
minute steps. See the first step in
'Exploratory contour drawing' on
page 84 (A). He then added more
lines (B), followed by five minutes
of colour (C).

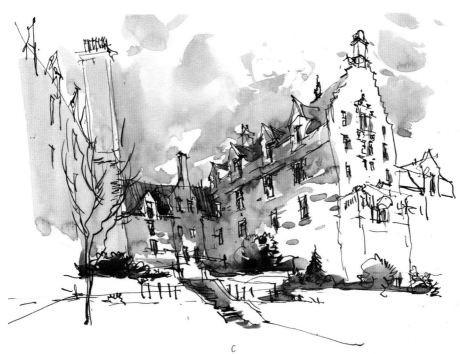

C

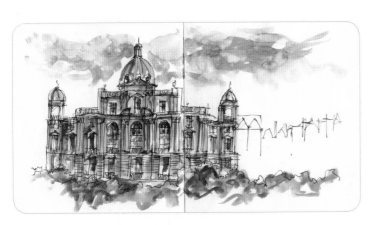

Left **Liz Steel**, *Bank of Scotland*
from Princes Street, Edinburgh,
UK, **2011.**
Arriving five minutes early for an
appointment, I decided to just draw
as much of this elaborate building
as I could and then add paint later
from memory.

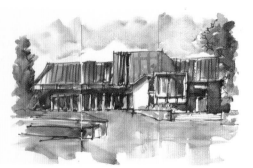

Left **Liz Steel,** *Macquarie Theatre, Sydney, Australia,* **2016.**
Drawing and painting over three surfaces (smooth, medium and rough) in one sketch really highlights the differences, especially in sky and foreground areas.

Right **Liz Steel,** *Macquarie University Library, Sydney, Australia,* **2016.**
The busyness of the glued-in floor plan of the library meant that I didn't need to include as much detail when I sketched the building.

Below **Inma Serrano,** *From my roof, Seville, Spain,* **2013.**
Using a craft paper sketchbook, Inma made the most of the opaque nature of her crayons to describe the white buildings in her scene.

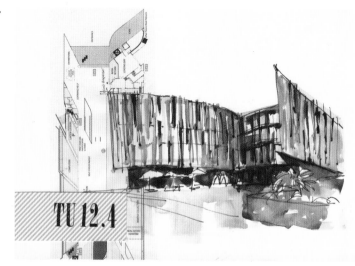

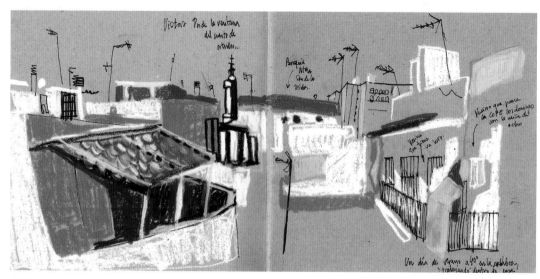

Play with paper

There is an enormous range of paper and sketchbooks that you could choose for your fast sketching. However, it's not just the properties of the paper that provide options. If it's bound in a book, the format and the binding will also impact on how well it suits your sketching. The best thing is to simply make a selection and test it out!

Tips to get you started

1 **Your materials** The media that you want to use for your sketching will dramatically affect your selection of paper. If you want to use watercolour, you'll have to find paper that is thick enough to cope with the application of water. Ink likes smooth surfaces best and watercolour is easier on rougher paper, so if you are working in ink and wash, then strike a happy medium between these two extremes.

2 **Smooth paper** Paper with a very smooth surface will generally be lovely to draw on with ink, but watercolour will sit on the surface, creating lots of hard edges. Therefore, it might not be the best choice if you're wanting uniform washes and work wet-in-wet. However, there are a lot of fun textures that can be created by using a smooth paper and quick brush strokes.

3 **Rough paper** Using pen on rough paper can be 'rough going', as it will skip across the surface; but pencils can create lovely textured lines. Watercolour loves rough textures, especially granulating pigments, so if you're not using a lot of ink, it's worth testing it out. There is a range of paper surfaces from medium to rough, so have fun exploring which you like working on the most.

4 **Coloured paper** Don't limit yourself to white or cream paper; try out darker ones as well, such as grey or brown craft paper. Toned papers are great for experimenting with opaque media such as crayons and gouache, and are especially eye-catching when white is added. You don't need to add as much colour on these papers, making sketching faster.

5 **Collage** Adding some patterned paper or printed sheets to your page before you start can help to speed up your sketch. Not only does collage take away the fear of the blank page, but its visual interest means your sketch has less work to do. Drawing over collaged paper can lead to some unexpected and exciting results.

Go digital for speed

The great thing about using a tablet or smartphone for sketching is that your tools are simple – just one device and a stylus – and yet you have endless possibilities. Of course, the unlimited options provided by a sketching app can mean that it's hard to get started! Battery life when you are out on location can be an issue as well, so this is added incentive to work quickly.

Tips to get you started

1 **App and stylus** Assuming you already have a tablet, the biggest decision you have to make is which stylus to buy. Look for pressure-sensitive ones, as they give the most options. There are many apps available, but just choose one to start with, like Procreate, and try it out. What you want to look for is how easy it is to change your pen/brush options.

2 **Keep it simple** When you are starting out, limit your options and focus on getting a feel for drawing with a stylus and quickly using the menus to change tools. Test different pen and brush alternatives and then choose one of each as a starting point. Then get really familiar with these so you can adjust quickly while you work. Begin working with just two layers – one for line and one for colour.

3 **Clean up later** One of the really great features of digital sketching is that you can easily erase and clean up areas later. This means that you can be freer and quicker with your strokes – especially if you are colouring within black outlines (like traditional ink and wash) – and can then clean up the edges when you are back home.

4 **Don't undo** Although the undo/rewind option is a very powerful feature of sketching apps, you must put it out of your mind, as it will undermine the confidence of your lines – something that is essential for fast sketching. Just keep going and learn from your mistakes for the next sketch.

5 **Step it up** Once you have mastered the basics and have built up the speed at which you can make tool selections, it is time to really explore more features, like creating palettes of your favourite colours, more complex layering and custom brushes.

2. Finer opaque strokes for the lighter elements

1. Top layer with shadows using more transparent brushes and multiply setting

Right **Rob Sketcherman,**
***VVG Bistro, Taipei, Taiwan**, 2016.*
iPad sketching guru Rob used
lots of fancy tricks, including
custom brushes for the
landscaping and a variety
of brush sizes and types.

Below **Luis Aparicio,**
School of Fine Arts Courtyard,
***Old San Juan, Puerto Rico**, 2011.*
In this simple black and white
iPad sketch, Luis used the
smudging tool to great effect,
contrasting it with finer, more
precise lines.

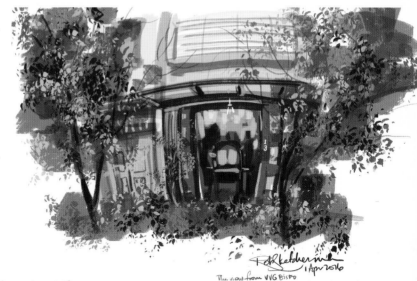

Bottom **Liz Steel,** *Local house,*
Sydney, Australia, 2016.
While I'm only a beginner in this
radically different medium, I tried
to replicate my usual mark making,
using only two brushes and with
varying opacity.

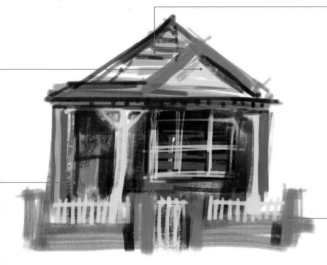

4. Bottom layer with
main colours using
textured brush

3. Second layer with
blue elements in front
of building

Sketch off the page

Now that you are developing the essential fast-sketching skills and know that you only need five minutes to sketch, you will have to remember to carry your kit and sketchbook with you everywhere. But if, by chance, you forget your gear one day, here are a few ideas for sketching on whatever you find at hand.

Tips to get you started

1 **Absorbent surfaces** When 'sketchbook-less', look around for other papers to draw on. For example, in a café there are always serviettes; these are very absorbent and if you hold your pen in one spot for too long you will get a bleed dot. In which case, quick decisive marks with a very light touch are the way to go.

2 **Resistant surfaces** Other papers may have a coating, and it's easy to think that they would not be suitable to paint on. Never let that thought put you off trying! Test them, and you might get some amazing results. If the paper is a little resistant to water, apply a fairly dry wash, and then once it is dry add another layer over the top.

3 **Surprises** You never know when you will find a surface that is really good for sketching, such as the inside of cardboard boxes, or the back of car parking coupons (popular in Singapore).

4 **Found objects** Don't just think about paper. Maybe you can draw over the top of natural objects, such as a leaves, bark or rocks. This would create a very real connection with the place you are sketching. However, make sure it's OK to remove these objects from the site and take them home with you.

5 **Addicted to sketching** If you have reached the state of mind where you are always looking for opportunities to sketch, even when you don't have your sketchbook with you, then you have definitely reached the status of an addicted sketcher! Congratulations. Keep it up! Never stop taking risks and attempting sketches in five minutes!

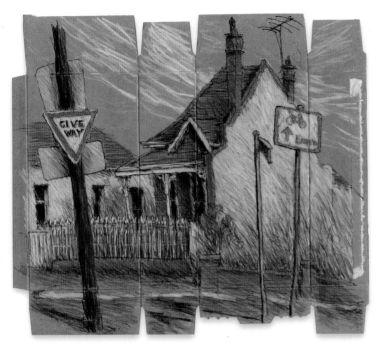

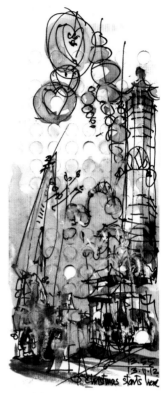

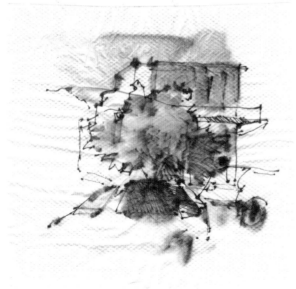

Above **Asnee Tasna**, *Orchard Road, Orchard Road, Singapore*, 2012.
The punch-out parking coupons of Singapore have a surprisingly great surface for sketching on, and the perforations are a special bonus!

Above left **Peter Rush**, *Llewellyn Street, Sydney, Australia*, 2014.
A cereal box not only provides a wonderful ground for Peter's coloured pencils, but the profile of the unfolded box adds a lot of character as well.

Left **Liz Steel**, *Local café view, Sydney, Australia*, 2016.
Because of the extremely absorbent nature of the serviette, I had to work fast and with a light touch in both pen and paint.

Index

Acknowledgements

Author Acknowledgements

I would like to thank everyone who has followed my sketching adventures since I first started posting my work online in 2008, especially Gabi Campanario and the worldwide community of Urban Sketchers. It has been an incredible journey and your encouragement and constant views have spurred me on to keep sketching and sharing!

Thanks to everyone who has enrolled in one of my workshops or SketchingNow online courses. You all inspire me constantly and your feedback helps to refine my thoughts. Much of the content in this book is a result of that.

It has been such an honour to include the gorgeous artwork of all the contributors. Your work has made this book much richer – thank you! Everyone at RotoVison has been great to work with: Alison Morris, Abbie Sharman, Nick Jones. Huge thanks to my friends Chris Haldane and Chantal Vincent, who helped enormously with editing and image coordination. And lastly to my wonderful family, especially Mum and Dad, who support me in so many ways – thanks!

Picture Acknowledgements

Alomar, Richard 28, 93
nycsketch.blogspot.com

Andrews, Peter 55, 77, 107
flickr.com/photos/panda1grafix/
paadesign.com.au

Aparicio, Luis 56, 112, 123
SketchfullyYours.com

Brehm, Matthew 90, 97, 108
brehmsketch.blogspot.com

Chapman, Lynne 101–2, 116
lynnechapman.net

Cruz, Tiago 19, 63
Avista.naocoisas.com

Dewhurst, Murray 68
aucklandsketchbook.com

Fijten, Rene 47, 59
renefijten.nl

Green, Daniel J. 12, 16, 59
@danieljverde

Hein, Virginia 12, 89, 94, 98
worksinprogress-location.blogspot.
 co.uk

Holmes, Marc 85–6, 120
citizensketcher.com

Hsiung, Carol 15, 36, 78, 111
flickr.com/photos/48097026@N02

Padrón, Luis Ruiz 24
luisrpadron.blogspot.com

Priollaud-Stoclet, Delphine 45, 64
croquis-en-voyage.fr/blog

Richards, James 27
jamesrichardssketchbook.com
flickr.com/jamesrichardsdrawings

Rush, Peter 32, 72, 111, 125
srarchitects.com.au

Seidel, Isabell 16, 41, 48
isabellseidel.com

Serrano, Inma 35, 60, 120
dibujosypegoletes.blogspot.com.es

Shirodkar, Suhita 31, 51, 67, 71, 108
sketchaway.wordpress.com

Sketcherman, Rob 123
sketcherman.com

Tasna, Asnee 20, 52, 68, 82, 115, 125
atasna.blogspot.com